S0-ABP-303

8.18.21
$ 4.00

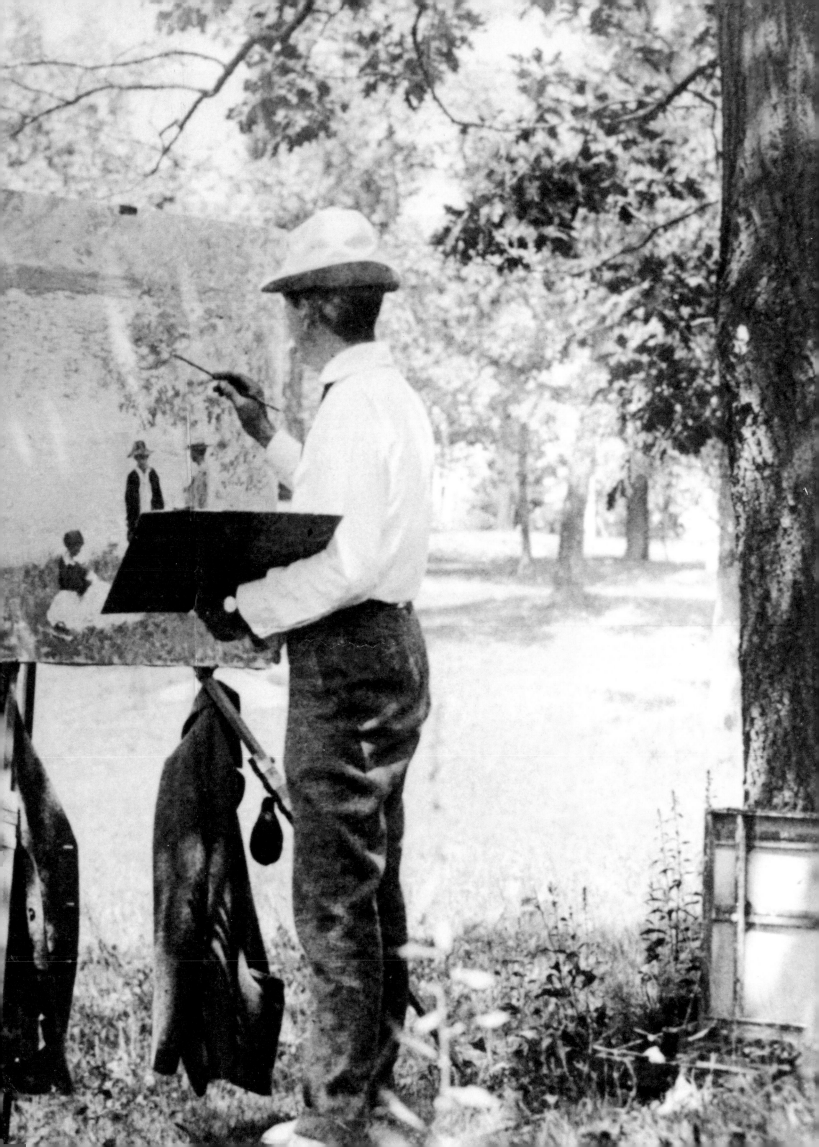

An American Impressionist

THE ART AND LIFE OF ALSON SKINNER CLARK

An American Impressionist

THE ART AND LIFE OF ALSON SKINNER CLARK

Deborah Epstein Solon

Introduction by William H. Gerdts

Pasadena Museum of California Art

Hudson Hills Press

First Edition
© 2005 Pasadena Museum of California Art
490 E. Union Street, Pasadena, California 91101

All rights reserved under International and Pan-American Copyright Conventions. Except for legitimate excerpts customary in review or scholarly publications, no part of this publication may be reproduced or transmitted in any form or by any means, electronic or mechanical, including photocopying, recording, or information storage or retrieval systems, without permission in writing from the publisher.

Published in the United States by Hudson Hills Press LLC, 74-2 Union Street, Manchester, VT 05254.

Co-Directors: Randall Perkins and Leslie van Breen
Founding Publisher: Paul Anbinder

Coordinator and Editor: Terry Ann R. Neff,
 t.a.neff associates, inc., Tucson, Arizona
Designer: Susan Evans, Design per se, New York
Proofreader: Richard G. Gallin
Indexer: Enid L. Zafran
Color Separations by Pre Tech Color LLC, Wilder, Vermont
Printed and bound by CS Graphics Pte., Ltd., Singapore

Distributed in the United States, its territories and possessions, and Canada by National Book Network, Inc.
Distributed in the United Kingdom, Eire, and Europe by Windsor Books International.

Frontispiece:
Alson Clark painting in upstate New York, c. 1912
Collection of Jean Stern, The Estate of Alson Clark

An American Impressionist: The Art and Life of Alson Skinner Clark was prepared on the occasion of the exhibition of the same name, organized by the Pasadena Museum of California Art, on view at the Gibbes Museum, Charleston, South Carolina, from May 27 to August 7, 2005 and in Pasadena from September 14, 2005 to January 8, 2006.

Library of Congress Cataloguing-in-Publication Data
Solon, Deborah Epstein.
 An American Impressionist: The Art and Life of Alson Skinner Clark / by Deborah Epstein Solon; introduction by William H. Gerdts.—1st ed.
 p. cm.
 "Pasadena Museum of California Art."
 Catalogue of an exhibition organized by the Pasadena Museum of California Art, at the Gibbes Museum, Charleston, South Carolina, May 27–Aug. 7, 2005, and in Pasadena in 2005.
 Includes bibliographical references and index.
 ISBN 1–55595–244–5 hardcover (alk. paper)
 ISBN 1–55595–252–6 softcover (alk. paper)
 1. Clark, Alson Skinner, 1876–1949—Exhibitions.
 2. Impressionism (Art)—California—Exhibitions.
I. Pasadena Museum of California Art. II. Gibbes Museum (Charleston, SC) III. Title.
 ND237.C54A4 2005
 759.13—dc22

 2004014442

Contents

Foreword

In 2001, when Deborah Solon approached me about organizing a retrospective of the work of Alson Clark, the Pasadena Museum of California Art (PMCA) had not yet opened. In fact, our first meeting took place just three months after the museum's groundbreaking. As the founding director, I was charged in my first year to create an exhibition program that demonstrates the PMCA's mission to explore in depth the achievements of California artists and designers from 1850 to the present. I was familiar with Dr. Solon's other exhibitions and projects, and I appreciated the fresh perspective that she brings to the evolving field of early twentieth-century California painting. The Alson Clark exhibition was a logical extension of her previous research and also would provide the PMCA with a landmark exhibition that would help build a wider public awareness for an important California artist.

The exhibition was well suited to the PMCA on other important levels. Here was an opportunity to highlight the work of an artist whose years on the West Coast were spent primarily in Pasadena, an important artistic center in early twentieth-century California. Clark, who died in 1949, was a well-known figure and remains in the living memory of this community. In addition to scholars and collectors, this exhibition has attracted notice from those who remember him and were familiar with his studio, which still stands today on the eastern rim of the Arroyo Seco overlooking the Rose Bowl.

The exhibition is also uniquely appropriate because it is Alson Clark's first full-scale museum retrospective. Over the past twenty years, Clark has been included in a wide range of exhibitions focusing on California art. In 1983, under the auspices of the Petersen Gallery in Los Angeles, Jean Stern orga-

nized an exhibition and published a catalogue that situated Clark's work within early twentieth-century painting. The extraordinary quality of his art presented in that exhibition raised the question from scholar and collector alike: when will there be a comprehensive survey of his paintings? Building upon that original scholarship and more recent exhibitions and publications, the PMCA is honored to celebrate Alson Skinner Clark through this publication and exhibition.

The present exhibition is the result of an enormous amount of effort by many individuals but I must offer my heartfelt thanks first and foremost to Dr. Solon. It was her initiative, organization, and intelligence that brought this project to completion. She oversaw the research, loans, and fundraising and helped on every aspect of the publication and exhibition tour. It is a rare pleasure to work with a curator whose enthusiasm and commitment to excellence were unwavering from start to finish.

The production of this accompanying catalogue— a major monograph on Alson Clark—would not have been possible without the direction of Terry Ann R. Neff. Her expert guidance at every step has been instrumental in creating an important and beautiful document. I also thank Dr. William H. Gerdts for his assistance with this project and his keen insights recorded in the book's introduction. We are grateful to Leslie van Breen at Hudson Hills Press for recognizing the importance of this project and supporting it from its earliest stage.

An American Impressionist: The Art and Life of Alson Skinner Clark will also be on view in Charleston, South Carolina, and we extend our thanks to Elizabeth Fleming, Executive Director of the Gibbes Museum of Art, and to Curator Angela Mack.

Alson Clark created a number of paintings in South Carolina, so we are particularly pleased by the museum's participation.

The staff at the PMCA has been a critical support throughout the exhibition. Exhibition Director Rebecca Morse oversaw the organization of all aspects of the publication and exhibition. Development Director Joslyn Treece assisted in raising support for the exhibition through foundations and corporations. Registrar Shirlae Cheng skillfully coordinated the shipment of all of the works. Emmett Clements and his installation staff brought their creative skills to bear on the gallery design and installation of the paintings. Executive Assistant Emma Jacobson-Sive helped with the myriad of details as they related to my responsibilities.

Finally, I thank those whose financial support for this exhibition enabled the PMCA to undertake such an ambitious project. Major underwriting for the exhibition came from Paul and Kathleen Bagley and PMCA Board Member Reed Halladay. Additional support came from Thomas and Barbara Stiles, Ranney and Priscilla Draper, Edenhurst Gallery, DeRu's Fine Arts, Mark and Donna Salzberg, Earl and Elma Payton, Gerald Buck, Spanierman Gallery, Lee and Sandra Minshull, Herb and Earlene Seymour, William and Daryl Horton, William Selman, Robert and Susan Ehrlich, and Robert and Nadine Hall. Finally, I thank PMCA founders Robert and Arlene Oltman for their ongoing support of the PMCA exhibition program and their vision for raising awareness of California artists.

Wesley Jessup, *Director*
Pasadena Museum of California Art

Acknowledgments

As with any major undertaking, *An American Impressionist: The Art and Life of Alson Skinner Clark* represents years of research and writing. The book first took form as my doctoral dissertation for the Graduate Center of the City University of New York. The members of my dissertation committee, professors Kevin Murphy, William H. Gerdts, and Diane Kelder, and Dr. David Dearinger provided excellent and insightful criticism. Particularly meaningful were the years of prodding, cajoling, and support from Professor Gerdts, who believed that I could and should complete the dissertation. I am honored that he has written the introduction for this book.

The history of Alson Clark has been infinitely enriched by the cooperation of the artist's family, Deborah Clark, Ellen Clark, Mancel Clark, Edwin H. (Toby) Clark II, and Robert Ober (Pete) Clark, who graciously offered information and recollections concerning their great-uncle. Deborah and Ellen made available letters and diaries never before published. Edwin generously shared genealogical information on the Clark and Skinner families, and provided unpublished black-and-white photographs of the Clark family home on the St. Lawrence River.

I am indebted to the staff of the Archives of American Art, Smithsonian Institution, Washington, D.C., for access to the unmicrofilmed Alson Skinner Clark Papers. I owe a special debt of gratitude to my good friends Phil and Marian Kovinick (Archives of American Art, San Marino, California). These dedicated researchers selflessly offered their time and expertise to assist in gathering archival material that was essential to this study.

Many colleagues, collectors, and dealers have provided information on the whereabouts of Clark paintings. I am especially indebted to George Stern, Ray Redfern, Whitney Ganz, Thom Gianetto, Josh Hardy, and Patrick Kraft. Jean Stern, whose pioneering book on Clark was first published in 1983, provided essential photographic material and offered his insights. Other individuals to be acknowledged include the following: Dan Abiri, Kathleen Updyke Barrett, Eric Baumgartner, Chonita Earle, Roberta Haltom, Robert Hicklin, Jr., Colleen Hoffman, William Horton, Dr. Andrea Husby, Michael Johnson, Michael McCue, James Reiser, Andrew Schoelkopf, Jason Schoen, Dr. Jessica Smith, Gavin Spanierman, and Paula and Terry Trotter.

I am grateful to Dana Solow for her research assistance and enthusiasm. Among the many helpful librarians and archivists, I specifically acknowledge the following: Peter Blank, Ryerson and Burnham Libraries, The Art Institute of Chicago; Stephanie Cassidy, The Art Students League, New York; Lori Daniels, The School of The Art Institute of Chicago; David Gonnella, Los Angeles Public Library; Natasha Kahn, Pasadena Public Library; and Matthew Roth, Automobile Club of Southern California.

Without the lenders and financial supporters of this exhibition, this project would not have been possible. I owe them a lasting debt of gratitude. Wesley Jessup, Executive Director of the Pasadena Museum of California Art, had the foresight to accept this exhibition. He and museum staff have dedicated their time and energy to ensure that this project materialized. The staff of the Gibbes Museum of Art in Charleston, South Carolina, especially Angela Mack, believed in this project and helped secure the

Gibbes as a venue. My editor and dear friend Terry
Ann R. Neff, with whom I have collaborated on
several projects, has once again worked her magic.
Her superb editing skills are evident throughout the
book. Hudson Hills Press enthusiastically evidenced
their support by agreeing to publish the monograph.

Friends on both sides of the country have cheered
me on during innumerable occasions. My mother
has patiently offered support and buttressed my
spirits. Although my father passed away many years
ago, I could hear his voice of encouragement.
Finally, I thank my husband, Neil, and my daughter,
Alexandra, both of whom made adjustments in their
lives so that I might work on this study. They have
generously accommodated their schedules to allow
me the time and energy to pursue my scholarly work
and successfully complete this huge undertaking.
It is to both of them that I dedicate this work.

Deborah Epstein Solon

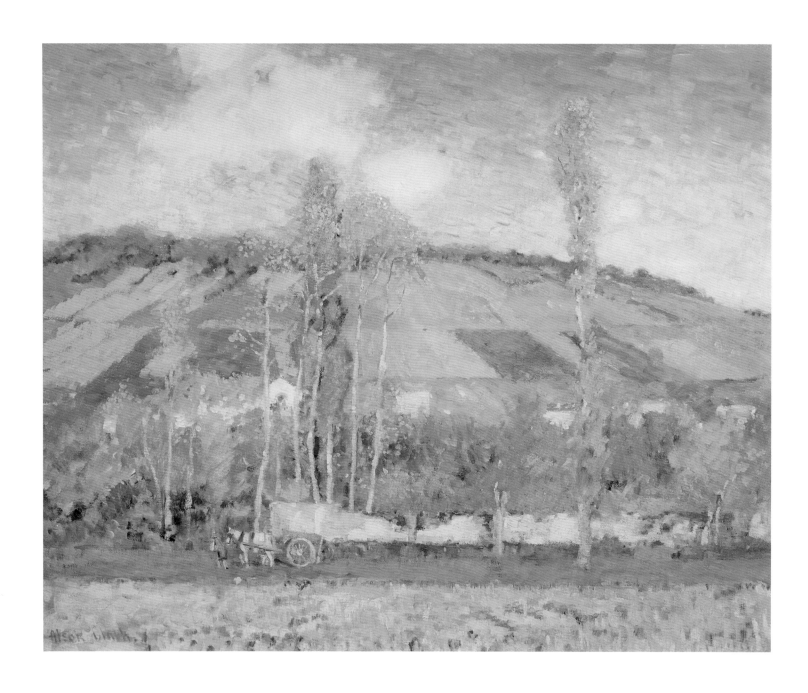

PLATE A

An Autumn Afternoon, Giverny, c. 1910

Oil on canvas, 25 × 31 inches
The Redfern Gallery, Laguna Beach, California

Introduction

William H. Gerdts

Professor Emeritus of Art History, Graduate School of the City University of New York

Over the last quarter century, since the exhibition "Impressionism, A California View" held at the Oakland Museum in 1981, followed by the publication of Ruth Lilly Westphal's *Plein Air Painters of California. The Southland* in 1982, and then the companion volume four years later, *Plein Air Painters of California. The North,* there has been a tremendous growth of interest in and appreciation for California Impressionists. Literally hundreds of publications and exhibitions have been devoted to the work of these painters who were active during the first three decades of the twentieth century, and concomitantly, hundreds of dealers have come to specialize in the promotion and sale of work that has become equally sought after by hundreds of collectors.

This is as it should be. No state or region of this country attracted so many able artists, drawn especially to record and interpret the color and light of the landscape of Southern California and also that of the Monterey Peninsula—the coastline, the hills and valleys, the mountains and the desert, and to a lesser extent though equally able, figural images and still lifes. Many of the numerous art museums in California have both held exhibitions of the work of these Impressionist painters and added an extensive number of examples of these pictures to their permanent collections, with the Irvine Museum and the Laguna Art Museum particularly specializing in examples of paintings by these artists.

The list of artists who have been identified as "California Impressionists" or "California Plein Air Painters" is lengthy and even appears seemingly endless as more and more little-known painters are unearthed. Others, previously considered "minor" figures, have become better known as more examples have surfaced to establish their superior artistic credentials. But there has remained a core group of these artists who have maintained their positions as the leaders of the Impressionist movement among California painters, among them Guy Rose, Maurice Braun, William Wendt, Granville Redmond, Edgar Payne, Euphemia Charlton Fortune, Joseph Raphael, and Alson Skinner Clark. Though hardly limited to the work of these artists, California collectors and dealers have sought out examples of these painters especially, with their finer achievements reaching sales figures into the six and occasionally seven digit numbers.

The celebration of the California Impressionists, however, has had its limitations in a number of ways. As with so much of "regional" art, both the collection and exhibition of the work of these painters has been confined to California. Only a few major collectors of California Impressionism outside of the state, such as the Bagleys in New Jersey, the Salzbergs in Florida, and the Fleischers in Arizona, have given serious consideration to the achievements of these artists. Likewise, exhibitions of their art, whether surveys of California Impressionism or one-artist shows such as the present exhibition of paintings of Alson Clark, have rarely made their way to institutions outside the state. And alternatively, exhibitions of American Impressionism, when organized in the East, have regularly tended to include such nationally lauded figures as Mary Cassatt, Childe Hassam, Theodore Robinson, John Henry Twachtman, William Merritt Chase, Willard Metcalf, and Julian Alden Weir, but their California counterparts, even the most distinguished, such as those previously named, are seldom included.

This is beginning to change, however. Slowly, the California Impressionists are starting to achieve national recognition in exhibitions and publications, and their works are appearing more and more in

commercial galleries in New York as well as in the major Eastern auction houses. Deborah Epstein Solon has been in the forefront of making this happen, most notably with her extensive and important 1999 exhibition for the Laguna Art Museum, "Colonies of American Impressionism: Cos Cob, Old Lyme, Shinnecock, and Laguna Beach." In this show, the artistry of Chase, Hassam, Metcalf, Twachtman, and Weir mingled very sympathetically with that of Rose, Payne, Redmond, and Wendt, among other Californians who were active in the art colony at Laguna Beach. This, indeed, is very much part of Solon's agenda: to effect a recognition that, while these California artists were, indeed, dominant figures in the state's art scene, each with a definable and recognizable aesthetic strategy, they deserve as well to be viewed and acknowledged as vital constituents in any overall evaluation of American art in the early twentieth century.

At the same time, Solon recognizes that there are more complex factors involved here, and that the Art Colonial movement was (and remains) only one of the many aspects of the art of the period among California painters that deserves to be addressed and redressed. Alson Clark did not, in fact, figure in her "Colonies of American Impressionism," for, though he painted at Laguna Beach, he was really no more a "member" of that colony than he was of the well-known Impressionist community in Giverny, France, which he briefly visited and where he also painted. What Solon has achieved here in her presentation of the art and life of Alson Clark is the enrichment and enhancement of his designation as a "California Impressionist" by questioning, though not denying, both aspects of that identification. In her catalogue essay, Solon explores the complexity of Clark's life, especially his fascinating peregrinations through

Europe and North America. Can Clark be considered not only a California Impressionist but also a French and/or Spanish Impressionist? He painted superb work from Quebec to Mexico and certainly had a great impact upon the artistic community in Charleston, South Carolina, which can rightly claim him as one of their foremost Impressionist artists. Probably his best-known sequence of paintings includes those that document the building of the Panama Canal—is Clark, therefore, a Panamanian (or Canal Zone) Impressionist? In fact, he was all these and more, for he exhibited regularly in both New York and Chicago, the latter especially, where he certainly enjoyed sustained patronage, while his most "orthodox" use of the Impressionist methodology—that is, closest to the work of Claude Monet—was probably sustained in some of the paintings he produced in upstate New York.

But in her essay and in this exhibition, Solon also demonstrates that Clark's identification as an "Impressionist" obscures the totality of his artistic achievement. In a fair number of his finest pictures, the impact of James Abbott McNeill Whistler, with whom Clark had studied in Paris, is paramount—pictures in which subtle tones rather than brilliant colors dominate, and in which both pattern and mood reflect a Whistlerian concept of "art for art's sake." And although this may be more true of some of his earlier work, this is not a simple matter of chronology. As with many painters—and to the aggravation of many art historians—Clark chose those artistic strategies that best suited the scene or subject that stimulated him at the particular moment of inspiration. Later in his career, when he became involved in mural painting, clarity of form dictated that his rich color sense be wedded to careful linear and formal considerations, which necessarily superseded the exploration of California's natural light and atmospheric effects.

Solon presents us here with a clear picture of the
totality of Alson Clark's pictorial accomplishment,
but the questions she raises, and the limitations of
his identification she addresses are not Clark's alone.
Clark had a fulfilling career long before he settled
in California in 1919, with some of his finest and
most celebrated pictures behind him. His friend
and colleague Guy Rose, probably today the best-
known of all the "California Impressionists," spent
even less time actually painting in California—
only from 1914 when he returned to his native
state, to 1921 when he suffered a debilitating stroke.
And Joseph Raphael, perhaps the most original of
all the so-called California Impressionists, spent the
totality of his professional career in The Netherlands
and Belgium, returning to San Francisco only
in 1939, at the beginning of World War II, many
decades after he had ceased to paint within an
Impressionist format. Clearly, then, this exhibition
and monograph not only celebrate a remarkable
talent but also recognize, even demand, a more
intricate and nuanced understanding of both regional
and aesthetic identifications.

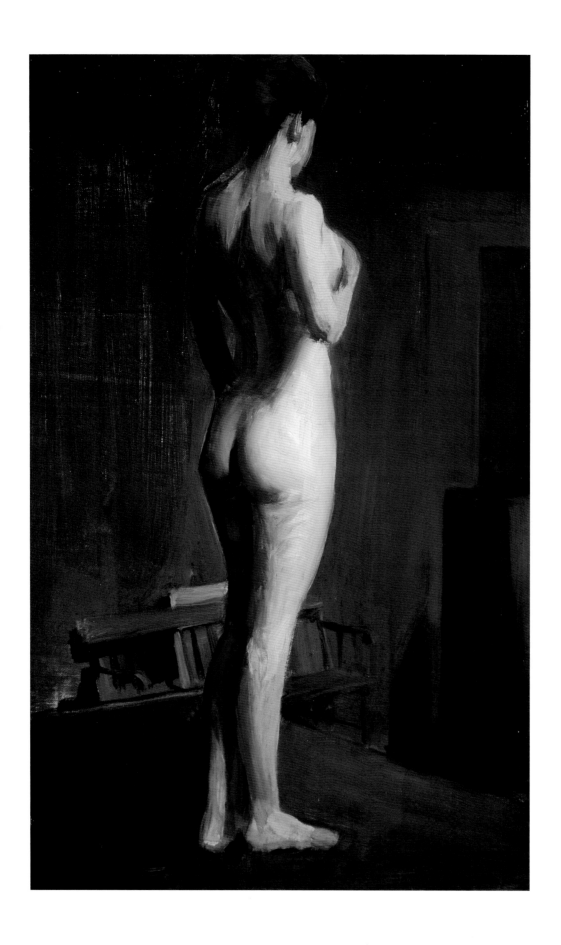

PLATE I

Early Nude, c. 1898

Oil on canvas, 24×15 inches

DeRu's Fine Arts, Laguna Beach, California

The Art and Life of Alson Skinner Clark

Deborah Epstein Solon

Alson Skinner Clark (1876–1949) is hardly a familiar name, even to those intimately involved in the study of American paintings of the late nineteenth and early twentieth centuries. His obscurity is only partially explicable. His student career—which included periods at The Art Institute of Chicago, the Art Students League of New York, The Chase School of Art (later renamed the New York School of Art), and the Académie Carmen in Paris—paralleled those of some of the best-known American painters. He counted William Macbeth in New York and William O'Brien in Chicago among his dealers. An expatriate for a significant number of years, Clark was a more peripatetic and intrepid traveler than many Americans who lived abroad, yet he exhibited throughout America during his lifetime and was a respected teacher in his mid-career. Surely all of these elements should qualify him for at least some modest recognition in the annals of art history.

However, Clark's life—and ultimately the obscuring of his career—was influenced by his move to Pasadena, California, in 1920, and his subsequent classification as a "California Impressionist." While Clark spent a portion of his career living in Southern California, which he painted with verve and enthusiasm, he is best understood as a cosmopolitan artist whose career encompasses but is not necessarily defined by his time in the Southland. He studied in Chicago, New York, and then Paris with two of the most significant figures in the history of American painting at that period: William Merritt Chase and James Abbott McNeill Whistler. Clark's style is informed by a modified form of Impressionism, but Whistler's art exerted an enduring influence on his palette and point of view.

Clark's life and career were marked by crucial moments and rather clear divisions. His artistic maturity paralleled his chronological maturation and dates from his marriage to Atta Medora McMullin in Watertown, New York, in 1902 and the onset of their extensive travels in Europe. He became associated with dealers and exhibited in major cities such as New York, Chicago, and Paris.

The second period of his career encompasses the Clarks' two trips to Panama to witness the building of the Panama Canal. Eighteen of Clark's paintings of its construction were exhibited in 1915 at the Panama-Pacific International Exposition in San Francisco. Returning to the United States because of war in Europe, the Clarks visited New England and Charleston, South Carolina, and the artist was able to solidify his standing at home.

When the United States entered World War I, Clark enlisted in the military and literally abandoned painting. He served as an aerial photographer in Europe, returning home unscathed except for an ear ailment that required him to seek out a warm climate.

Unfamiliar with California, after an initial visit in 1919, the Clarks relocated to Pasadena in 1920. This move marks the last chapter in Clark's life. The landscape, beautiful missions, and proximity to Mexico all offered the painter new and exciting possibilities. By the late 1920s, Clark had become known for mural paintings—a novel aspect of his career but a source of fame and financial stability in uncertain economic times. Nevertheless, throughout his prolific and extensive career, Clark always maintained his devotion to Impressionism—to painting *en plein air*—never abandoning his commitment to his work or his vision.

Student Days

Alson Clark's early years (1876–1900) spanned a momentous and turbulent period in this country's history. The United States was still recovering from the political and financial difficulties of the aftermath of the Civil War. American art, however, advanced to a new level during the 1870s and 1880s. Great institutions were founded, among them The Metropolitan Museum of Art in New York (1870) and the Museum of Fine Arts in Boston (1876), along with any number of universities and libraries. It has been skillfully argued that the centennial was the point of departure for the American Renaissance, a period rife with social contradictions but one that allowed the arts to flourish on a grander scale than ever before envisioned.[1]

Clark's Chicago childhood was privileged. Musing on Alson's early interest in art, Medora stated:

> I think the desire to draw was always extant with Alson Skinner Clark. When he was nine or ten years old, it made itself manifest—and obnoxious as well—to his church-going parents, for during the long Sunday sermons he surreptitiously recorded the bonnets and bald pates in front of him in the only place available at the time—the frontispiece and blank rear pages of the family hymnals.[2]

She recalled that Alson's "professional" career began in grammar school. The curriculum included freehand drawing, and Clark sold drawings for fifty cents to those boys who lacked talent or interest.[3] Clark's entrepreneurial streak notwithstanding, his parents did recognize their son's creative talents, and enrolled him in three evening classes at The School of The Art Institute of Chicago between October and December 1887.[4] Alson's knowledge of art and culture was further nourished in 1889 when his

family, including his brothers Mancel and Edwin, embarked on a two-year trip around the world. Although Clark's father was from an impoverished background, he had built a highly successful commodities business at the Chicago Board of Trade. His situation allowed him to leave the operation of the business to his brother and join his family for the Grand Tour.

The European voyage was a defining period for the nascent artist. Clark kept a diary for 1889, writing about the food, weather, and his studies but also about the churches, museums, galleries, and opera performances the family attended. Upon their return, he completed his studies at the Chicago English High and Manual Training School and entered the School of the Art Institute as a full-time student. The traditional academic program (mostly dependent upon French principles) included requisite drawing from casts and still lifes before advancing to the live model. Clark took six courses from October 1895 to June 1896, but following a disagreement with one of his teachers and displeased with what he considered the slow and laborious process of drawing from casts, Clark quit the school.[5] Determined to continue his studies elsewhere, he decided to attend the Art Students League in New York.

Although his parents supported his intention to become a painter, Clark's mother, Sarah, was concerned about her son living alone in New York, so she went with him. Adding to the unusual arrangement, Alson's closest friend, Amelia Baker, joined them; the three shared a flat at Seventy-seventh Street and Columbus Avenue. According to Sarah Clark: "For two years Mela [Amelia] and I have talked of spending a winter in New York, in Bohemian fashion, and have searched for a good

Alson Skinner Clark, Black
and white illustration, c. 1896
Joint Diary of Alson Clark,
Sarah Clark, and Amelia Baker
Collection of Ellen Clark
Family Archives

reason for doing so, in vain till this time. Alson, however, came to the rescue in his desire to study art with a New York master, and made it seem a necessary thing to do."[6] Alson attended the Art Students League, whose traditional curriculum included supplementary courses in composition, modeling, and anatomy.[7]

As extraordinary as this living situation was the fact that the three kept a collaborative diary for the year, rotating entries. Alson's profuse sketches throughout the book often reflect on the day's activities. Although almost no student work exists, these charming, frequently whimsical, and often complicated sketches are a clear indication of his promise. His written entries characterize his student life and record observations of his flamboyant master, William Merritt Chase. The scholar Sarah Burns has described Chase in the following way:

> A highly public figure, Chase projected a particular pattern of artistic behavior associated with the most up-to-date, enterprising modes of art practice. He was prominent among a considerable number of contemporaries who shaped themselves in this mold, which rejected anything more than cosmetic eccentricity and sought to construct an image of competence, discipline, social skill, organization, and managerial acumen.[8]

Indeed, Chase's self-conscious mode of dress and other quirks only enhanced his pronounced impact upon an entire generation of American painters. When Clark arrived at the Art Students League in 1896, Chase's ten-year appointment at the school was about to end. When he left to form the Chase School of Art (later the New York School of Art), many students, including Clark, followed him. Chase

was a supportive instructor who was loathe to discourage his fledgling charges. Clark remembered a moment in their weekly criticism when the master, having nothing positive to say regarding a student's work, complimented the way he held his brush.[9] Chase encouraged his students to familiarize themselves with the great masters and then incorporate those lessons into a unique viewpoint.[10] Clark sympathized with Chase's methods, including drawing from life and allowing simultaneous instruction in drawing and color. He also developed a close relationship with various classmates, including Marshall Fry, Melvin Nichols, Lawton Parker, Eugene Ullman, and J. Coggeshall ("Willie") Wilson. The first semester had its triumphs and disappointments: "This morning I went to the studio and had a good crit on both of my drawings. Also had a crit on my painting, the first I have tried." The following week he lamented: "This morning went to the studio and got a fair crit on my drawing, but he thought my painting was a big joke."[11] A self-critical and determined student, Clark was no doubt additionally frustrated by his dubious health. Repeatedly ill, he went frequently to the doctor to have his stomach "pumped." His gastrointestinal ailments ultimately resulted in an operation in 1900.

When the semester ended in May, Clark returned to his family home, one of the Thousand Islands of Alexandria Bay, New York, on the St. Lawrence River, which the Clark family purchased in 1882. The house was dubbed "Comfort Island," after Old Point, Comfort, Virginia, where the family had previously spent time.[12] By June, Clark left for Long Island, to attend Chase's Shinnecock Hills Summer School of Art.[13]

The Southside Railroad Line reached the East End of Long Island in 1868, hastening the area's growth.

Wealthy New Yorkers discovered the pristine beaches and shores. Feeling a cultural void, they raised funds and persuaded Chase to open a summer school in Shinnecock. In operation between 1891 and 1902, the school attracted an influx of students anxious to paint *en plein air*. Clark's colleagues that summer included Fry, Ullman, Wilson, and Charles Webster Hawthorne. Clark roomed with Ullman and Wilson in a farmhouse a short distance away from the Art Village, the nucleus of the community, with its studio and residential cottages.

Clark's diaries and correspondence offer insightful and blunt assessment of the routine. Students worked independently, going to Chase for criticism at various times during the week. The informality allowed students greater access to Chase, and the master was well disposed toward his students.[14] Ample leisure time allowed Clark opportunity for his passion for kite flying. Nevertheless, Clark left at the end of June for Comfort Island, although with regret: "I am very sorry to leave this place, as I have had a good time and learned a lot. If I come next year I will miss all the folks I have known this year in the worst way."[15] However, the young artist was also happy to spend time on the island, a period that became especially precious in the wake of his move to New York and separation from his loved ones.

Returning to New York in the fall of 1897, Clark rented a comfortable apartment at 82 Lexington Avenue. Longing for the emotional support of family and friends, he confessed to Amelia: "I miss not having someone to talk to about the day's success and failures and adventures, and the good reading and drinking we had last winter. . . . I will probably miss our family flat a lot more before the winter is over."[16]

Living alone for the first time forced Clark to confront adulthood. He was ambivalent about his progress, occasionally feeling confident and alternatively stating, "I am not doing half I can."[17] That February, Clark had an unexpected experience: "I painted a figure last week and Chase came around and worked on it and made a daisy thing of it, so I have kept it, as it is almost a 'Chase' although I did put on the color but he pushed it around and made it fine."[18] The painting, *Early Nude* (plate 1), bears an inscription on the verso reading "Prof. W. Chase worked on this." A nude model, with her back to the viewer, stands on a platform in a studio. Her outlines are well articulated but not rigidly so. Flesh tones are broadly painted with transparent highlights that seem to illuminate the figure. The application of paint definitely reflects not only Chase's influence but Clark's own hand.

By March 1898, even the self-effacing Clark had to acknowledge that he was progressing. He admitted to Amelia: " I am working hard now and painting most of the time and I find that it helps my drawings a great deal as I have to see the big masses and the planes much better. . . . I get surprised at the work I am doing now compared with the bad stuff I did last winter."[19] He left in June for another summer at Shinnecock, renting a farmhouse with Ullman and two other students.[20] The large grounds included a corncrib, barn, two chicken houses, and twenty chickens. Their neighbor allowed the boys to construct a makeshift golf course on her lot.[21]

Twice during that summer, Chase kept works that Clark submitted for criticism; the second time, he offered a substantial compliment: "[Chase] said he considered one of them the truest things he had ever seen done in his class. I expect to leave here a week from Tuesday, and I will be very sorry to go as I am getting much interested in my work and am getting along, I guess."[22]

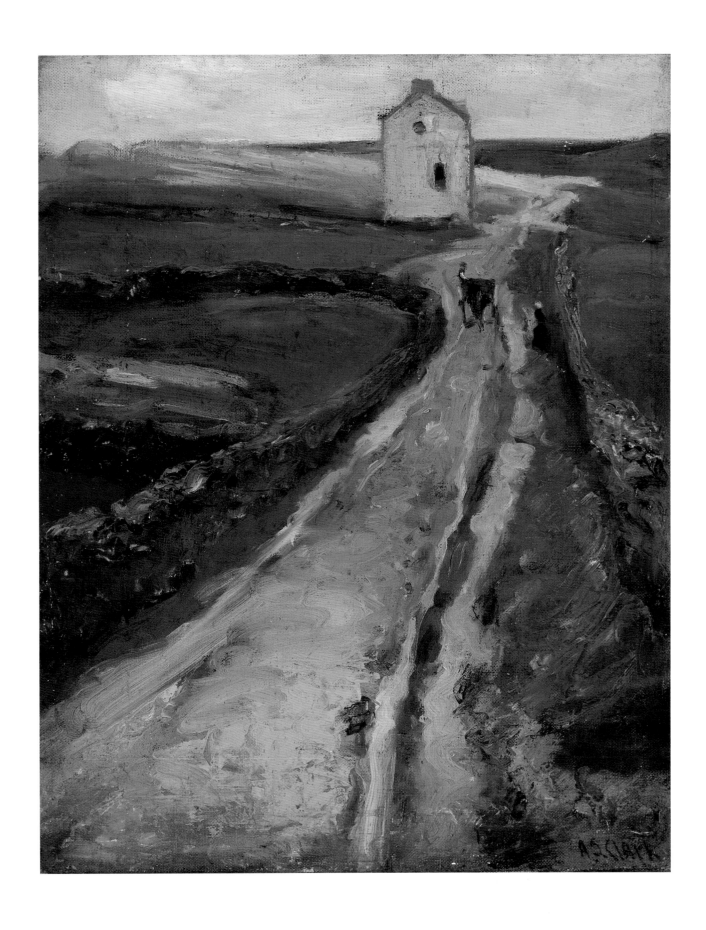

PLATE 2

Landscape near Le Pouldu, France, c. 1900

Oil on canvas, 16×13 inches
DeRu's Fine Arts, Laguna Beach, California

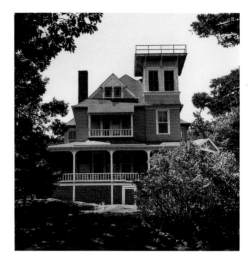

"Comfort Island," the Clark family
home in Thousand Islands,
Alexandria Bay, New York, 1973
Photograph by Alce Ann Clark Cole,
courtesy of Edwin H. Clark II

Interestingly enough, Clark's diary does not discuss his plans to leave for Europe in the fall. He had considered going abroad since the beginning of the year. According to Medora, there was substantial correspondence and debate that summer regarding the merits of different transatlantic steamships.[23] Clark returned from Shinnecock to Comfort Island for several months. He recorded his reservations about leaving his family only in November, when his voyage was imminent: "My dear Mama, how I hate to leave her for so long. I do love her so."[24]

On November 5, 1898, along with his classmates "Willie" Wilson and Melvin ("Nic") Nichols, Clark sailed for Europe on the S.S. *Marquette*. Arriving in London on November 16, the group immediately sought out the museums and visited John Singer Sargent's studio.[25] On November 23, they left for Paris, where they met Parker and Ullman, both of whom were already established with studios and apartments. Taking up temporary residence at the Hotel Minerve, the group began to look for studios the following morning. A disheartened Clark complained that they were all "gloomy and dirty."[26] A decision was made to temporarily share a studio with Ullman and remain at the hotel. In the meantime, they visited the Académie Julian, which Clark found "disgusting."[27] Securing an apartment proved less daunting: a place was engaged at 17, rue du Dragon. Within a few days, the group enrolled at Whistler's atelier, the Académie Carmen, in Montparnasse.

The decision to join Whistler's atelier was surprising. Whistler was vitriolic and pugnacious—the antithesis of Chase. Clark's initial reaction was that the school was "rotten."[28] Whistler spent a career alienating clients and other artists, Chase among them. His behavior was notorious and deliberately cultivated—not easily lending itself to beneficial teaching and indeed probably a cause of the school's failure in 1900.[29] Although by the end of December, Clark wrote that he and his colleagues had "quit the Whistler school for good as there is no room to work and we are now busy in the studio all day,"[30] they continued to attend intermittently in between hiring models to work in their studios.[31] Clark confided to Amelia: "I am sort of in that stage where I know a lot about what I would like to do but can't do it and no master could help me figure that out. I have to grind it out for myself and when I have gotten through that stage I will go back to Whistler again and get some more good."

In spite of himself, Whistler's art embodied the ideals of the Aesthetic Movement. "Whistler's portrait of his mother," wrote an admiring Clark, "always looks better the more one sees of it and one cannot see it too often." On New Year's Day, 1899, Whistler held a rare small soirée for his students at the studio. There Clark acquired insight into Whistler's working methods:

> He showed us several of his starts and finished pictures. They were elegant and really almost came up to the Old Masters. His things are so simple that you look at them a moment and everything comes out but nothing pushes itself forward so that you notice it specially but see the whole thing. . . . He arranges his palette very queerly. He first has black, then raw umber, light red, burnt sienna, Prussian blue, burnt umber, some more black, vermilion, raw sienna, yellow ochre and white. . . . His studio is very dimly lighted and all the walls are of a warm, dark pink.[32]

Unfortunately, almost none of Clark's early student work in Paris (c. 1898–1900) remains. However, it is evident that by 1901, Whistler had a profound effect on Clark, even to the way he arranged his own palette.

Although Clark was acclimating to life in France, he remained doubtful as to his progress: "You never saw such a horribly uncertain painter as I am. One day I can paint and get quite tickled with myself and the next day and for a week I can't put down a thing that suits me or anywhere near it and feel quite discouraged."[33] In March, he entered his first work in the Salon.

> Wednesday Wilson and I went to the Salon to see the stuff carried in and all the awful things that went in—I never saw such a lot of bad painting. The wagons come up to the entrance and take their wads of pictures in and there are crowds of people watching the stuff enter. I have little hope that [my picture] will pass the jury but one can never tell as there is a great deal of "pull" in the Salon, and as I have not studied under any Frenchman I may be thrown out. I don't care what happens although of course I would rather be in than out. Exhibitions are, after all, a farce.[34]

When his painting was rejected in April, Clark pretended indifference: "It doesn't matter to me at all as I haven't a reputation to make and there isn't much honor in being in unless you get in squarely as only very few do. . . ."[35] Nonetheless, inclusion continued to be his goal and when his work was accepted for the first time later in 1901, he was hardly nonchalant.

That spring, Clark suffered increasing physical infirmities. Told that he needed an appendectomy—a serious operation at the time—he booked passage back to America on June 1 and scheduled the surgery in Chicago for the first week of July.[36] After recuperating for several months, Clark returned to Paris in November, determined to stay at least one more year. He set up a studio at 7, quai Voltaire and began what proved to be a productive transitional time. Clark began to paint the city of Paris—its parks, bridges, and buildings. When *The Violinist* (plate 3) was accepted, and "hung on the line" at the Salon, a Chicago newspaper suggested that "the happiest man in all Paris. . . was Alson Clark, a young Chicago artist. Miss Fortuna presented him with notification from the jury of the coming Spring Salon in the art center of the world that of five pictures submitted by Mr. Clark, one had been accepted."[37] *The Violinist* is the first clear indication of Whistler's impact on Clark. A solitary figure holding a violin and poised as if about to play is placed in the background of an austere room. Muted hues, with an emphasis on brown and green, create a somber, brooding mood. The primary sense is of a compositional arrangement—the placement of the solitary individual and the exploration of dark color—as opposed to interest in personality or narrative. Clark's reliance on Whistler would become even more pronounced within the next few years. *In the Fog* (plate 6) presents a hazy, obfuscated environment in which a fountain and a group of figures appear indistinctly in the foreground, barely articulated by a few brushstrokes. This exploration of color harmonies and aesthetic relationships is an homage to Whistler.

Clark remained in Europe for the spring and part of the summer. He went to the Breton town of Le Pouldu with a group of friends, among them, Frederick Frieseke. Clark had visited Le Pouldu the previous summer, but this year he remained nearly three months. Clark and Frieseke shared a similar

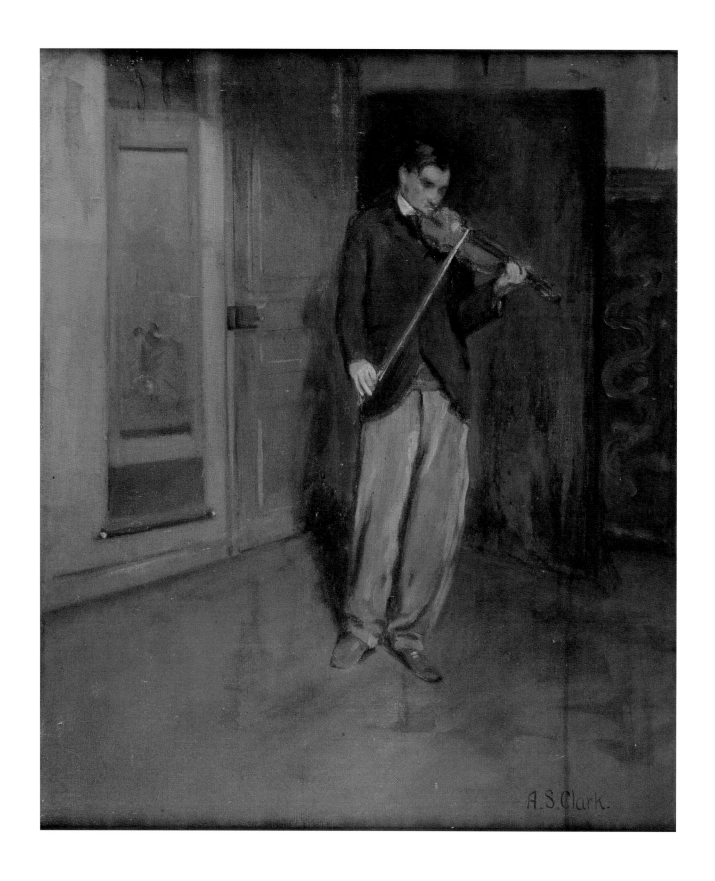

PLATE 3

The Violinist, c. 1901

Oil on canvas, 26×22 inches
Huntington Library, Art Collections and Botanical Gardens, San Marino, California,
Gift of Alson Clark, Jr.

22

student history. They overlapped in 1895–96 at The School of The Art Institute of Chicago, where they may have met. Undoubtedly they had become acquainted when both studied with Chase at the Art Students League in New York.[38]

Le Pouldu was an established art colony, hosting at various times the likes of Paul Gauguin, Childe Hassam, Walter Griffin, and John White Alexander. It has been suggested that artists working in Le Pouldu were typically associated with the *Bande Noire* or "Black Gang," a faction of the Nabis closely identified with Charles Cottet and Lucien Simon, who depicted Breton locals in rather dark tonalities.[39] Clark had briefly studied with Simon and Cottet at the Académie de la Grande Chaumière in Paris. One of Clark's paintings from his first summer, *Landscape near Le Pouldu, France* (plate 2) may be a reference, both in terms of palette and composition, to the "Black Gang." A road leads the viewer into a deep spatial recession. The slightest suggestion of two figures working in the field is juxtaposed to a solitary house. The palette is a dark mixture of browns, greens, and beige, and Clark's brushwork is sketchy and loose.

At the end of the summer, Clark returned home to Comfort Island. In the fall, he rented a barn in Watertown from Amelia's parents and converted it into a studio. His decision to stay in Watertown marked the beginning of his professional career and heralded a new chapter in his personal life. He had gained experience and sophistication through his sojourn in Paris. Now, still strongly influenced by both Chase and Whistler, he began to develop a personal vocabulary.

Marriage and Early Career

In 1901 Clark settled at his Watertown studio for the long and snowy winter. Watertown was a small, provincial city near Lake Ontario and the Canadian border. Not surprisingly, Clark was the only professional artist in the area. In addition to his own work, Clark taught drawing classes to some local students. Atta Medora McMullin, a girl with whom he was acquainted, agreed to serve as a model for portrait painting. Medora recalled: "A painter... was not completely understood nor exactly welcome, and posing was completely new to me, but I dressed in a costume he had selected and, accompanied by my mother, descended to the studio."[40]

Medora regularly posed for Clark, and love bloomed, despite the artist's apprehensions. "In the evening I would have liked to have seen Medora, but stayed home and wrote. I have no more business in marrying than the man in the moon for I am fickle and can't help myself. It is a misfortune and not a fault." Yet, just a few days later, he wrote, "In the afternoon she posed. I could not work as I wanted to tell her that I loved her but could not. We sat by the fire knowing each other's minds."[41] By the end of January, Clark professed his love and the two decided to marry.

During the winter of 1902, Clark worked on *The Black Race* (plate 4), a winter scene of a wash along the Black River near Watertown. Bare vertical trees stabilize the foreground, leading back to a row of squalid apartment buildings. The river is partially frozen, the scene bleak. Jean Stern has observed that in both subject and treatment, this work evokes the influence of Robert Henri and The Eight,[42] but it is important to distinguish Clark's interpretation from that group's often cynical social commentary. Clark neither sanitized his scenes nor invested them with a subtext or social agenda. He submitted this work

to the Society of American Artists exhibition in New York and received an acceptance letter.

March was a noteworthy month. With Medora's help, Clark organized his first solo exhibition in Watertown of several dozen small paintings. Always cognizant of his obligations, on the eve of the exhibition, Clark wrote: "Tomorrow begins my career as an artist and with that the knowledge that some of my works may bring us our living."[43] In fact, financially he was more fortunate than most artists. In the 1890s, his father had purchased the Wadsworth-Howland Paint Company (later renamed the Jewel Paint Company), in the hope that his sons would enter the business. Although the boys proved uninterested, the business provided income for the artist and his siblings throughout their lives.

The exhibition of small works depicting the city of Paris was a thrilling experience for the Clarks: "There is nothing so exciting, so tremulous, so breath-taking as the preparation for the first show, and I have always been grateful that I was in on it, though at the time I hardly understood what it was all about...."[44]

Approximately forty people attended, and a few pictures were sold; Medora considered the event a "grand success."[45] From Watertown, the paintings traveled to Chicago for Clark's first major exhibition, at the Anderson Galleries. Critical response was overwhelmingly positive for the "Chicago boy," with a consensus that the "young man certainly has decided talent." The *Chicago Tribune* declared, "popular opinion has decided that it is a very promising display for a young artist.... Mr. Clark has a style of his own. It is suggestive of Japanese reminiscences, is refined and pleasantly frank.... The sentimental does not interfere with the boldness of using masses."

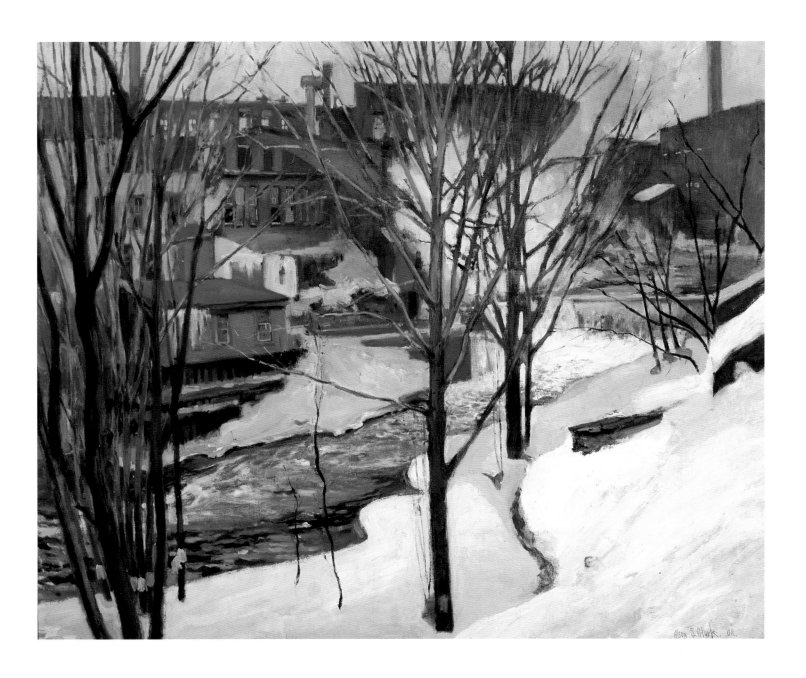

PLATE 4

The Black Race, 1902

Oil on canvas, 30×38 inches

Collection of Robert and Susan Ehrlich

It was recognized that Clark was a neophyte, but one with tremendous potential. The reviewer for the *Chicago Times Herald* summed it up in the following way:

> These forty pictures are tangible tokens of an unusual talent that will undoubtedly achieve recognition when it has reached its full development. It is not claimed for these pictures that they are the masterpieces of a finished artist, but rather a collection of studies from the brush of a very clever student.[46]

Clark faced a new challenge when he accepted a mural commission in 1902 for a Chicago elementary school. Although he had no experience as a muralist, the school under construction was to be named in honor of his great-uncle, Mancel Talcott, a successful businessman.[47] It is safe to assume that nepotism played a role.

Clark chose as subject the Pied Piper of Hamelin, an allegory based on the Robert Browning poem.[48] He worked on the mural throughout the month of July, using local children as models. Although the overall composition manages to maintain its integrity, Clark did have some problems articulating the scale. He would not attempt a public mural again for over twenty years—until he was settled in California and established in his career.

Following their wedding on September 30, 1902,[49] Alson and Medora sailed on the S.S. *Minnetonka* for a planned European stay of undetermined length. On November 7, they moved into an apartment at 6, rue Victor-Considérant in Paris. That same month, Clark recorded that he was attending the Académie Vitti with "Willie" Wilson. He continued to focus on Parisian cityscapes, such as a scene painted from the vantage point of his apartment, *From Our Window, Paris* (plate 5). This bird's-eye view of Montparnasse, including the cemetery in the middle ground, is done in a brighter palette, awash in an overall luminosity. Clark was beginning to test his versatility as an artist: his studies of boats on the Seine, street vignettes, and Whistlerian figure studies explored and challenged the boundaries of his interests and capabilities.

Not long after the Clarks settled into their apartment, Frieseke returned to Paris and took rooms just above the couple. Medora wrote that Frieseke actually lived with them before finding his own accommodations.[50] Among the constellation of American artists in France during the early twentieth century, Clark's friends included such notables as Lawton Parker, Will Howe Foote, Henry Hubbell, Richard Miller, and Guy Rose. However, he was especially close to Frieseke in the early years.[51] Frieseke painted from the Clarks' apartment balcony (*The Balcony*, 1904, Private Collection), and used Medora as a model in works such as the *Green Sash*, 1904 (Collection Terra Foundation for the Arts, Daniel J. Terra Collection).

The two artists shared a deep appreciation of Whistler and explored the theme of women in their boudoirs—both clothed and nude. The dialogue between the two is evident in a comparison of Frieseke's *Sleep* (1904, Watkins Collection, American University, Washington, D.C.) and Clark's *Reclining Nude* (plate 29). Both artists present sleeping, recumbent women in an interior setting. The figures are painted in creamy flesh tones and recline on bedcovers. Both paintings have erotic overtones that are tempered by the somnambulance of the sitters— a condition that renders them "innocent." While academic in the devotion to outlines, both works

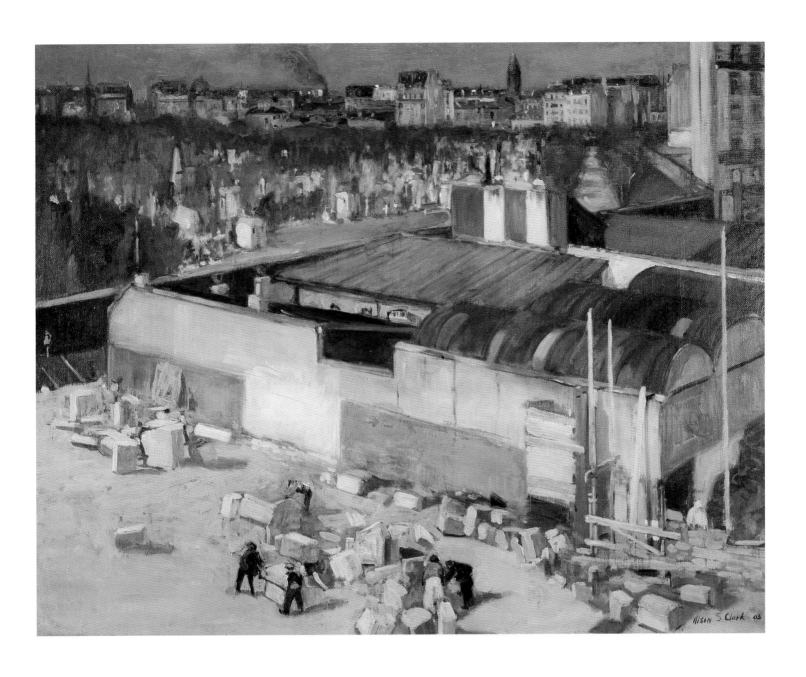

PLATE 5

From Our Window, Paris, 1903

Oil on canvas, 25×31 inches

Collection of W. Donald Head/Old Grandview Ranch

PLATE 6

In the Fog, 1903

Oil on canvas, 10½ × 13¾ inches
Collection of Mr. and Mrs. Kerry McCluggage

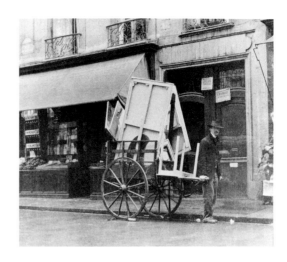

Taking paintings to the Salon,
Paris, c. 1905
Collection Jean Stern,
The Estate of Alson Clark

have loosely painted passages that suggest Impressionistic leanings. Frieseke and Clark, like so many of the American painters, maintained this duality of technique, successfully integrating numerous interests and influences.

Medora's recollections of the Clarks' years abroad are an invaluable record of conditions for American painters in Paris during the early twentieth century. At first, Clark was one of the few married men, and the couple's apartment became a focal point for friends and acquaintances. Artists sought out each other for moral and occasionally financial support, for intellectual discourse, and for fun. Life took on familiar patterns. The Clarks often spent Sundays at the Louvre or viewing a current exhibition; they frequently attended a church service. Daylight was precious and finances limited, so the couple regularly retired to bed early instead of going out—contrary to what some of their American friends imagined was a boisterous Parisian social life.

The painters worked assiduously during the winter in order to prepare for the spring Salon. As part of the preparation, many artists analyzed each other's works—by invitation—offering blunt assessments. Some assisted each other when it came time to deliver paintings to the Salon, often renting and sharing wagons. They even exchanged formal clothing to wear at openings: "Many painters didn't possess the required outfit, so there would be a hurried return to some base, a quick exchange, and the frock coat and hat would make a second trip to the Salon on a smaller, but happy man."[52]

The Clarks were looking ahead to the summer of 1903 when a friend suggested they pool resources and rent rooms in an old château in Rochefort-en-Terre.[53] The town was isolated—five miles from the train station—and retained its unspoiled Breton charm. Clark was lured by the possibility of painting the medieval architecture and local population. Brittany, especially Rochefort-en-Terre, would become one of the Clarks' favorite haunts—several times a destination during their residency in Europe.

Returning to Paris in fall 1903, Clark resumed painting the city. *The Bridge Builders* (plate 8) explores the theme of construction (seen the previous year in *From Our Window, Paris)* and continues Clark's trend toward a brighter palette and more brilliant light. The subject is a specific moment in the construction of a bridge spanning the Seine, down to the detail of a worker on a ladder who is literally frozen in time. Wood scaffolding, docks for loading and unloading of material, workers carefully negotiating the scaffolding—all combine to create a monumental moment from fairly pedestrian activity. Such works prefigure Clark's iconic images of the building of the Panama Canal. A large, exhibition-size work, *The Bridge Builders* was shown at several venues, including the Lewis and Clark Centennial Exposition (1904) in Portland, Oregon, and the Society of American Artists (1905) in New York City. Correspondence substantiates that Clark was intentionally working on a larger scale: "I am busy as possible now with my stuff. I am doing some of my street scenes on a larger scale, and getting on very well with it. I think these are the first serious efforts I have made to do that [and] I hope to improve a lot."[54]

Although Clark continued to bemoan conditions at the Salon, his painting *Stone Cutters* was accepted in 1904. By that spring, his work was selling rather briskly in America, and he was represented at the Society of American Artists exhibitions for 1903 and 1904.[55] Sales and some unexpected financial

PLATE 7

A Breton Homestead, c. 1903

Oil on canvas board, 9½ × 13 inches
DeRu's Fine Arts, Laguna Beach, California

PLATE 8

The Bridge Builders, 1904

Oil on canvas, 30×38 inches
Collection of Mr. and Mrs. Anthony Podell

support from Clark's parents enabled the couple to finance a glorious Italian expedition.[56] In April and May, they visited Genoa, Pisa, Rome, Naples, Pompeii, Florence, Bologna, and Venice, meeting up in Venice with Lawton Parker and his wife.

Of the few extant images from this trip, *The Forest of Masts, Genoa* (plate 9) is certainly one of the most successful and complicated. The foreground is established by vertical masts of boats in the harbor, some placed parallel, others in opposition. In the middle ground are homes, and the scene is offset by white clouds in the expansive sky. The vigorous brush-work of the background—with color applied in dabs—is juxtaposed to the more subdued handling of paint in the foreground. The composition's play of opposing structural and technical subtleties results in a fascinating visual mélange. Fourteen Italian street scenes and figure studies (with Medora as the primary model) were exhibited at The Art Institute of Chicago in October.[57]

Clark documented many of his paintings in note cards and notebooks (often including a small photograph). Certain paintings he specifically deemed "Whistlerian," unabashedly stating his indebtedness to the master. *The Necklaces (Les Colliers)* (plate 11) is perhaps his greatest homage to Whistler's portraiture. Clothed in a flowing gown and placed in front of an elegant mantelpiece, Medora stands with her back to the viewer as she examines different necklaces. A mirror offers a reflection of her profile, focusing on her elongated neck and bare shoulders. The décor, including the floral wallpaper, jar on the mantel, and carpet, suggests Oriental influences. The painting is aptly compared to a work such as Whistler's *Symphony in White, No. 2: The Little White Girl* (1864, Tate Gallery, London).[58] The points of

affiliation are visually explicit, and both works challenge traditional notions of portraiture.

During the summer of 1905, the Clarks visited the Low Countries before returning to America in July. They spent time at Comfort Island before leaving in the fall for Chicago. Despite Clark's lifelong affinity for Chicago, he was well aware of New York's primary commercial importance, and at this time he began to develop a critical and ongoing relationship with the New York art dealer William Macbeth.

William Macbeth spent his career waging a persistent battle to convince the American public to purchase American, rather than European, paintings.[59] A standard-bearer for American painting, he was a trusted friend and advisor to artists and clients alike, and a twentieth-century tastemaker.

The first extant correspondence between Clark and Macbeth dates from October 1905, as Clark noted: "I am sending you today via American Express seven paintings which you so kindly asked to see. The two winter scenes are American. . . . I have several other American pictures I can let you have later."[60] Clark specifies them as "American," making a clear distinction between these and his European scenes. Several months later, after Macbeth facilitated the sale of Clark's *Snow in Watertown,* to William Merritt Chase, Clark acknowledged his indebtedness: "I feel deeply complimented of Mr. Chase's favor and wish to thank you for your kindness in aiding to place my work with such a distinguished man."[61]

The winter of 1906 was a watershed for Clark in several ways. It began with a one-person exhibition of forty-five European scenes and portraits at The

PLATE 9

The Forest of Masts, Genoa, 1904

Oil on board, 12½ × 15¾ inches

The Buck Collection, Laguna Hills, California

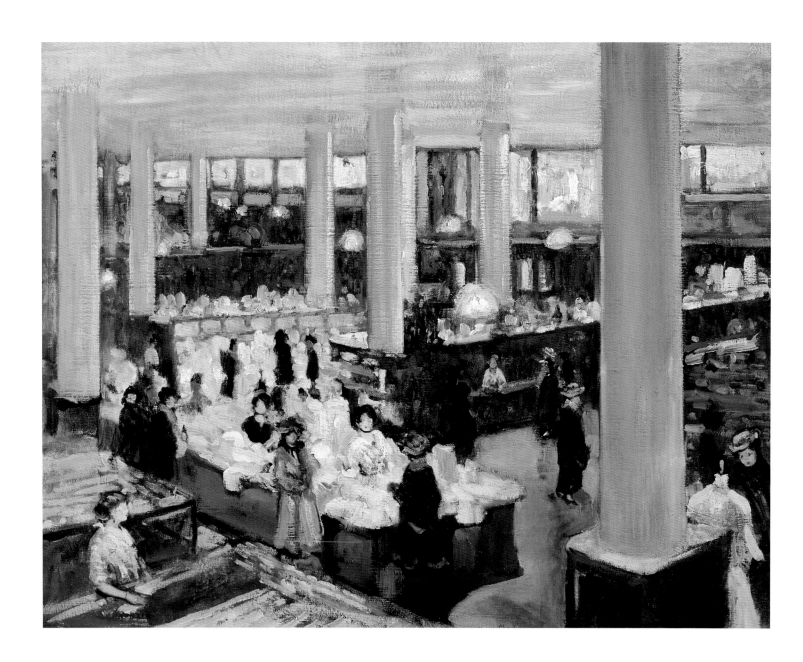

PLATE IO

Carson Pirie Scott Department Store, 1905

Oil on canvas, 24½ × 31½ inches

Collection of Robert and Nadine Hall

Art Institute of Chicago.[62] Frigid weather did not prevent a warm response:

> Mr. Alson Skinner Clark's . . . canvases, including portraits, sketches of Paris and Venice and other old-world haunts are in the spirit of men of the new salon who are painting from observation and taking their ways along the lines of art interpretation without the traditional methods of the older coterie. The old school artists led us to expect finished pictures, complete in composition and in brushwork. The man of the new salon studies values of color, light, and tone, and to him any bit of city or garden or roadside life furnishes pictures told briefly and to the point.

The Bridge Builders was singled out for its "treatment in color values" and *In the Fog* was recognized as an analogue for a state of mind: "Another of the strong introspective paintings is *In the Fog*. The artist has accomplished that most difficult of feats, the transmission to the beholder of the feeling of actual physical repugnance engendered by the spirit of the mist. He has not painted a scene. He has painted a human emotion."[63] The critic Harriet Monroe, who would become a staunch supporter of the artist, offered a positive, if tempered, review:

> Mr. Clark's exhibition is unequal, but considering the artist's youth, promising and shows a certain amount of real achievement. He is most successful in street and garden scenes, glimpses of crowds or rooftops by night or day, and at worst in his portraits. . . . Better than any single picture, I like the free and joyous spirit of [all] of them. It is this that charms, which convinces me that this young painter has real merits in him, in spite of his present incompleteness.[64]

Thrilled with the critical notices, Medora also suggested that Clark, no stranger to self-doubt, felt "established" for the first time.[65] Before the exhibition ended, Clark wrote to Macbeth, asking if he might be interested in taking some pieces for sale in New York.[66]

Clark also worked fervently during this period in Chicago. One of his more unusual paintings is the *Carson Pirie Scott Department Store* (plate 10). The landmark department store (built 1899–1904) was the architectural brainchild of Louis Sullivan, the father of modern architecture and especially the commercial skyscraper. Clark captured the interior of one section of the bustling store, using a highly Impressionistic style to show the movements of the patrons (mostly women) as they shopped. The focus is on spontaneity and immediacy: figures and merchandise are merely suggested by dabs of color and brush strokes. Clark has attained a new level of freedom in the handling of paint, a significant step toward his practice of Impressionist techniques. From this point onward, elements from the style vie with the more "Whistlerian" paintings of his early years.

Although Clark did not discuss the rising New York art star Robert Henri, he shared Henri's interest in urban life and was undoubtedly well aware of his art. Both artists exhibited at the Society of American Artists and were represented by William Macbeth.[67] However, Henri and The Eight (the group so named in 1908) shared a fundamental philosophy toward urban realism. Clark, on the other hand, was never an ideologue, and was neither interested specifically in urban realism nor in promoting nationalistic art. In some strategic ways, he was an opportunist, offering Macbeth "American" as opposed to European scenes because

that was Macbeth's interest. Clark functioned outside the orbit of political or social causes, using different subjects as a vehicle to explore various painting techniques.

During his stay in 1906, Clark transferred his interest in urban life in Paris to Chicago. Always affable, he befriended one of the bridge tenders on the Chicago River, who allowed him to paint in the lookout of the State Street Bridge. From this vantage point, looking out across the bridge, Clark produced *The Coffee House* (plate 16), named for the coffee warehouses in the area that emitted a constant aroma. The scene is relatively bleak—a cold winter's day in the warehouse district—with smoke billowing from factories and a haze covering the frozen streets. Barely recognizable figures make their way across the blustery bridge. The Whistlerian muted palette mirrors the overall sensibility. This amalgamation of Whistlerian tonalities and broad and loose Impressionist brushwork is an accommodation of two different sensibilities.

The painting was exhibited at The Art Institute of Chicago in 1906 and awarded the prestigious Martin B. Cahn prize.[68] It was also shown at the Society of American Artists in April 1906 and at the Pennsylvania Academy of the Fine Arts in 1907. It should be noted that Clark painted the State Street Bridge from other viewpoints, including a relatively small, yet effective, work with water in the foreground and the bridge in the background (plate 17), and a compelling industrial landscape (plate 14) that in no way sanitizes the often grim effects of industrial development. However, Clark's treatment does not indicate a distaste, but rather a profound interest in how his native city was transforming.

Following a relaxing summer at Comfort Island, the Clarks planned a trip to Japan for autumn 1906. After journeying to Quebec, their departure city, the couple were overcome with its beauty and Alson became increasingly anxious about the Japanese cuisine (having been warned off raw fish). They decided to remain in the charming, European-influenced city.

The couple settled in at what Medora described as a lovely lodging house and often ate at the hotel Château Frontenac. Despite the occasional subzero temperatures, Clark immediately began to sketch and paint *en plein air*, often needing snowshoes to naviagate. To keep his paints from freezing, Clark, with the help of a tinsmith, developed a long tin palette with a charcoal burner inside and a chimney at one end that allowed the paints to stay warm.[69]

Clark was quite prolific during those months in Canada, painting primarily landscapes and cityscapes draped in pristine white snow. In comparison with his winter scenes in Watertown, Chicago, and Paris, his palette was now considerably brighter; the white snow offered a perfect vehicle to explore reflections and shadows. *Toboggan Slide and Dufferin Terrace* (plate 18) is a view looking down over the city, with the Château Frontenac in the background. Quebec is divided into lower and upper portions, punctuated with steeply pitched roofs that shed the snow. In the foreground, Clark depicted a sweeping pedestrian bridge with a few hearty souls making their way in the freezing conditions; snow-covered rooftops and water dominate the background. Rooftops were a favorite subject of Clark's in Paris and continued to fascinate him throughout his career. Another work, *Winter, Canada* (plate 15), depicts the St. Lawrence River spotted with blocks of floating ice. Cool lavender and pale blue shadows reinforce the frigid

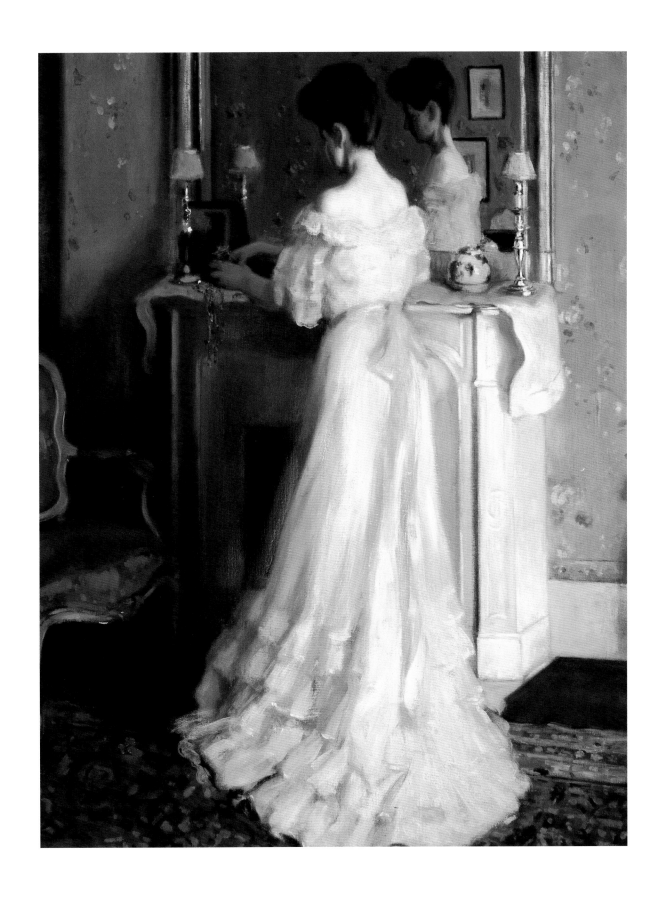

PLATE II

The Necklaces (Les Colliers), 1905

Oil on canvas, 38¾ × 30⅛ inches
Collection of Earl and Elma Payton

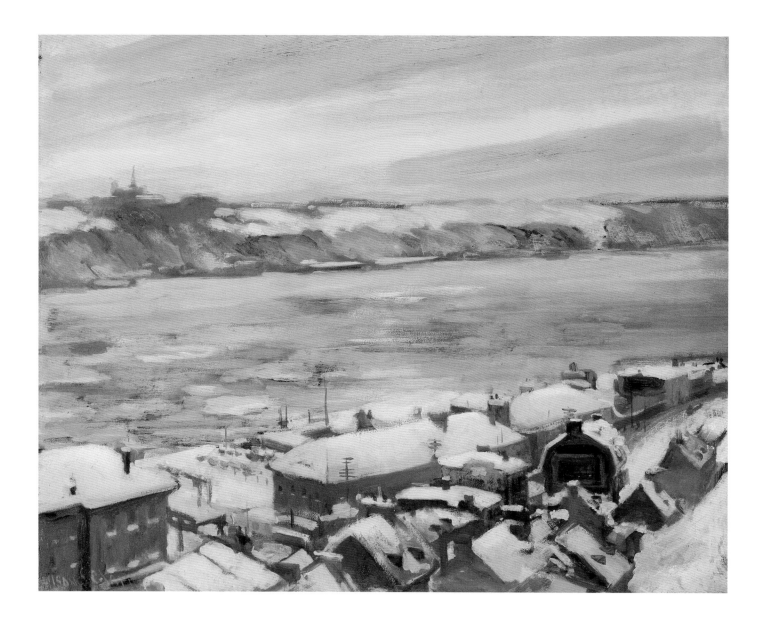

PLATE 12

Grey and Gold, 1906
Oil on canvas, 17×20 inches
Collection of Peter B. Clark Family Trust

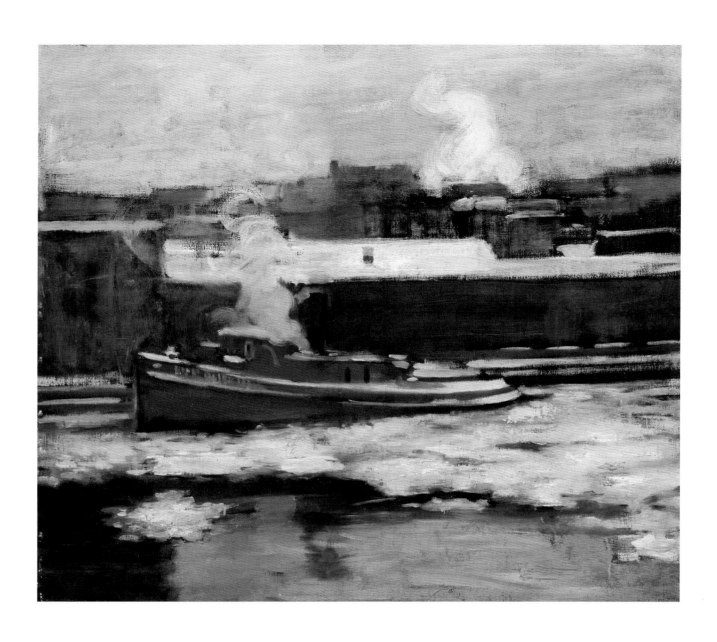

PLATE 13

Pushing Through the Ice, 1906

Oil on Masonite, 18×21½ inches
Spanierman Gallery LLC, New York

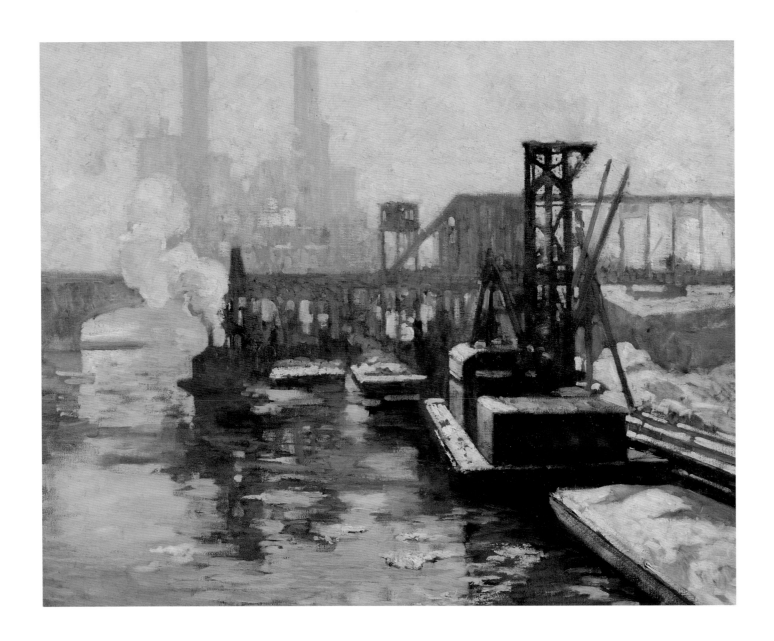

PLATE 14

Winter Industrial Landscape on the Chicago River, 1906

Oil on canvas, 26×32 inches
Collection of Saul A. Fox
Photo courtesy of Hirschl & Adler Galleries, New York

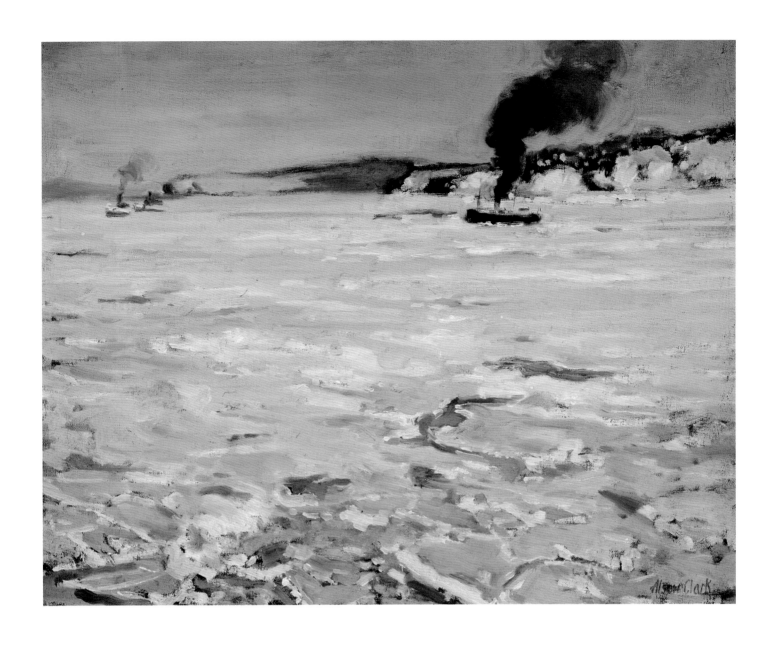

PLATE 15

Winter, Canada, c. 1906

Oil on canvas, 18×20 inches

Collection of Ken and Connie Ward, Carmel, California

temperatures. Varied brushwork creates a lively surface texture.

Other United States artists had worked in Quebec. Albert Bierstadt's *St. Lawrence River* and *View of the Parliament Buildings* (both c. 1880, National Gallery of Canada, Ottawa) are relatively early examples. Frederic Edwin Church painted there in the late nineteenth century (see *View of Quebec,* Wadsworth Atheneum, Hartford, Connecticut). By far one of the most prolific artists working in Quebec during the first decade of the twentieth century was Birge Harrison. He first visited the city in the winter of 1901 and returned during several succeeding winters.[70] Like Clark, Harrison was interested in exploring the atmospheric effects of snow and light. It seems likely that the artists overlapped in Quebec during the winter of 1906, although neither claimed an acquaintance. Harrison stayed at the Château Frontenac, and Medora specifically noted that the Clarks often ate at the hotel. Despite the lack of conclusive documentary evidence of a relationship, several works reveal striking similarities and invite speculation.[71]

In December 1906, with a number of works he thought worthy for sale, Clark contacted Macbeth:

I had intended to go to New York this fall to see you, but was unable to do so as I found a good opportunity to come to Quebec at that time. The winter has been in full swing here for some time and it is the most interesting place to paint in the winter of any that I have chanced to be in. Would it be too much to ask of you if I might send some of my canvases a little later, as I am sure they would interest you. The subjects are in most cases cheerful, that is to say in sunlight.[72]

One of the five paintings sent to Macbeth was *Grey and Gold* (plate 12). The title is obviously a tribute to Whistler; the key element here and during this entire period for Clark is light, which bathes the painting.

When the winter snow turned into spring slush, the Clarks decided to return to Paris. They found an apartment on the boulevard Saint-Jacques and acquired a rarely seen "tri-car," characterized by Medora as the "lowest form of automobile life." A combination motorcycle/passenger car, it was the latest rage in Paris as a replacement for horse-drawn delivery trucks. The two goggled riders—Clark wearing a waterproof leather suit and chauffeur's cap—must have looked comical. In inclement weather, they draped themselves and the contraption in an oilcloth apron.[73] Although the car spat, sputtered, and had to be pushed up sharp inclines, it enabled the Clarks to spend the summer and fall of 1907 exploring the château country.

Clark produced enough new small works (generally 7-by-9 inches) to have an exhibition that began in Chicago in 1908 and then traveled to numerous venues, including the Worcester Art Museum; The John Herron Institute, Indianapolis (now the Indianapolis Museum of Art); The Detroit Museum of Art; and the Albright Art Gallery, Buffalo (now the Albright-Knox Art Gallery). The critical reaction in Detroit represented the generally positive response: "In these studies the artist has not sought out for wonderful technical or color effects, but he has expressed himself with simplicity and directness. His colors are harmonious and one is charmed with the pictorial qualities of the scenes before him."[74]

The Clarks remained in America during 1908 and part of 1909, spending time on Comfort Island. Alson painted a significant number of portraits

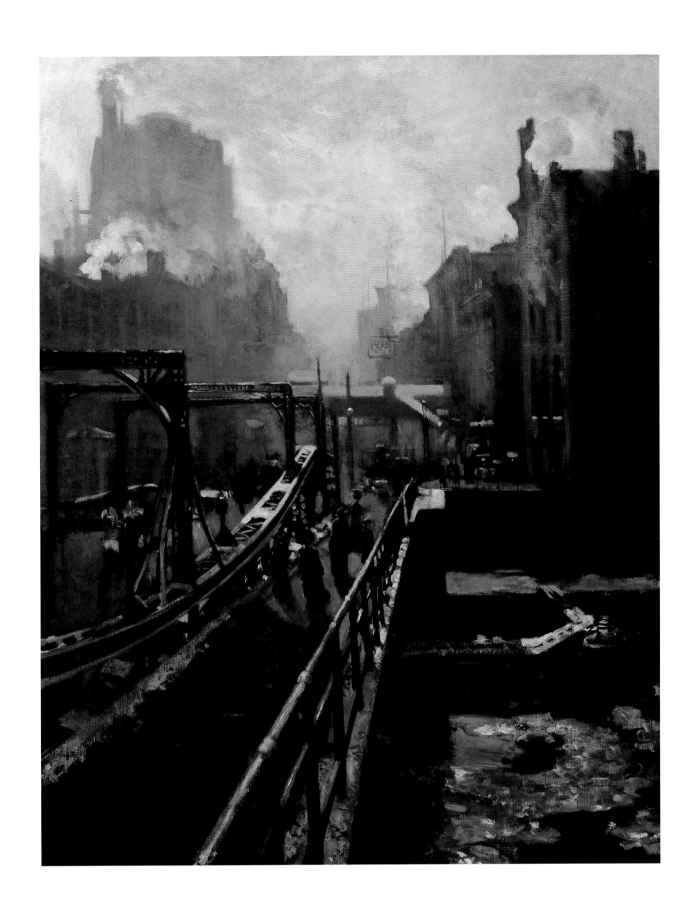

PLATE 16

The Coffee House, c. 1906

Oil on canvas, 30×38 inches
Collection of The Art Institute of Chicago,
Gift of Mr. and Mrs. Alson E. Clark

43

PLATE 17

State Street Bridge Along the Chicago River, c. 1906

Oil on canvas, 15 × 18 inches

Collection of Paul and Kathleen Bagley

St. Lawrence Seaway from the
Comfort Island verandah, 1973
Photograph by Alce Ann Clark Cole,
courtesy of Edwin H. Clark II

of Medora, their family and friends, along with several scenes of boat races on the St. Lawrence (see plate 23). The island was always a welcome interlude, yet Clark felt isolated from his colleagues. He submitted a few works to Macbeth in March 1909, but the dealer was unimpressed with them. Although rebuffed, the artist was grateful for the feedback. "I do not feel at all surprised that you did not like the picture from the [Pennsylvania] Academy and I am glad to get criticism on it. It is hard up here to do my work, for being the only artist I have only my own judgment to go on."[75] This speaks volumes to the importance of Clark's circle in Paris and the significance of interaction among artists.

In spring 1909, the couple had a propitious meeting with F. Luis Mora, a friend from the early days in New York. Mora had been to Spain the previous summer; he invited the couple to join him for the upcoming summer. Additionally intriguing was the fact that Spain was not a common destination for American painters.[76]

Spain was all they had hoped for and more. The Clarks stayed for five months. Medora called it a "marvelous country, everything Alson loved to paint, and he worked feverishly, producing beautiful canvases."[77] Stops included Malaga, Casarabonela (a town accessible only by mule trail), Granada, and Madrid. In Madrid they stayed on the Puerta del Sol, which served as the inspiration for one of Clark's large, important paintings of this period, *Plaza of the Puerta del Sol* (plate 19). The busy plaza, surrounded by buildings, offered a myriad of elements: streetcars, horse-drawn carriages, pedestrians, and donkeys collide in a kaleidoscopic whirl. This painting is reminiscent of the cityscapes of Monet and Pissarro executed from elevated vantage points.

While Impressionist sensibilities are evident in many of the Spanish works, Clark still maintained an aesthetic duality. *Plaza del Sol at Night* (1909, Private Collection) clearly references a Whistlerian nocturne.[78] Using a shorthand notation for the delineation of figures, lights, and buildings, the elements blend into a visual harmony. Clark's stylistic virtuosity—easily moving between sensibilities—is a leitmotif of his work from the first decade of the twentieth century, and an element of his ongoing search to find his own voice.

After Madrid and brief stops in Toledo and Segovia, the couple returned to Paris. Anxious to organize his Spanish paintings for an exhibition in America, the Clarks returned home in December and arrived in Chicago in January 1910.[79] A show of the Spanish paintings opened at the O'Brien Art Galleries on March 2. Seventeen of the thirty-eight canvases sold immediately. Macbeth agreed to exhibit works that were still available.

Fresh from this success, by June the Clarks were back in Paris. Part of the summer was spent in Normandy with Eugene Ullman and his family. Clark's Normandy paintings from this period are very much in the milieu of William Merritt Chase's Shinnecock beach scenes.[80] *Sunset, Normandy* (plate 25) can easily be compared with Chase's *At the Seaside* (c. 1892, The Metropolitan Museum of Art, New York) or *Idle Hours* (c. 1894, Amon Carter Museum, Fort Worth, Texas).

Placed against the backdrop of the shoreline and horizon, Chase's beaches seem endlessly elongated— a formal strategy Clark has certainly absorbed as a tremendous expanse of land spreads outward in either direction. The canvas is bathed in the soft purple and pink glow of sunset. Against a muted

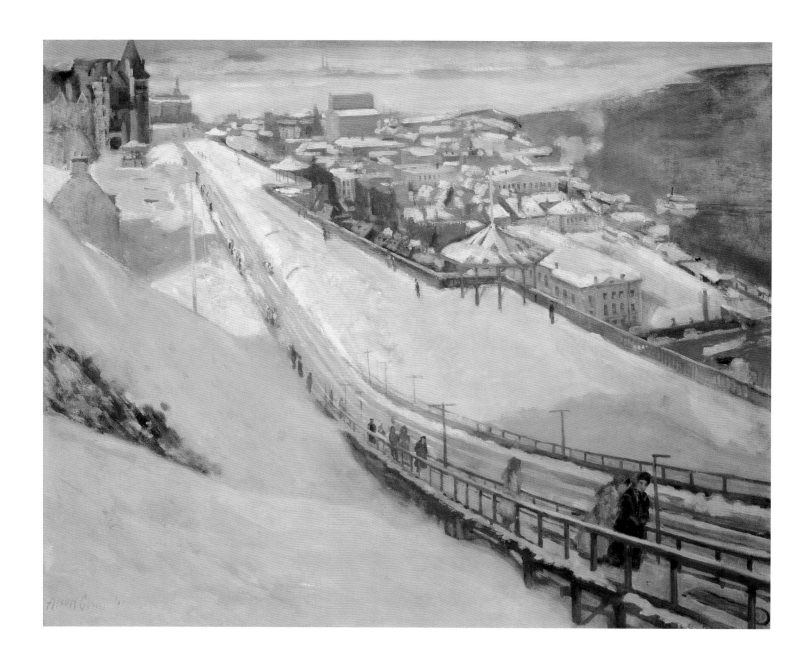

PLATE 18

Toboggan Slide and Dufferin Terrace, c. 1906

Oil on canvas, 30 × 38 inches
Edenhurst Gallery, Los Angeles

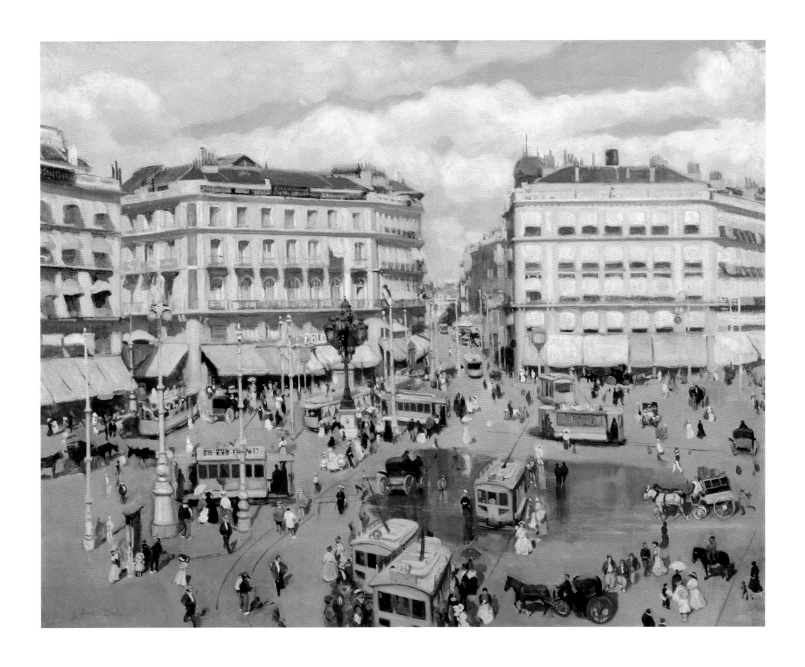

PLATE 19

Plaza of the Puerta del Sol, 1909

Oil on canvas, 30×38 inches
Collection of Paul and Kathleen Bagley

PLATE 20

The Rising Sun, Malaga, c. 1909

Oil on canvas, 11½ × 16 inches

Collection of Dr. Albert A. and Sharon M. Cutri

PLATE 21

Saint Gervais, c. 1909

Oil on canvas, 30½ × 38½ inches

Collection of the Union League Club of Chicago

PLATE 22

Summer, Giverny, 1910

Oil on canvas, 25¼ × 31⅛ inches

Collection of Mr. and Mrs. Thomas B. Stiles II

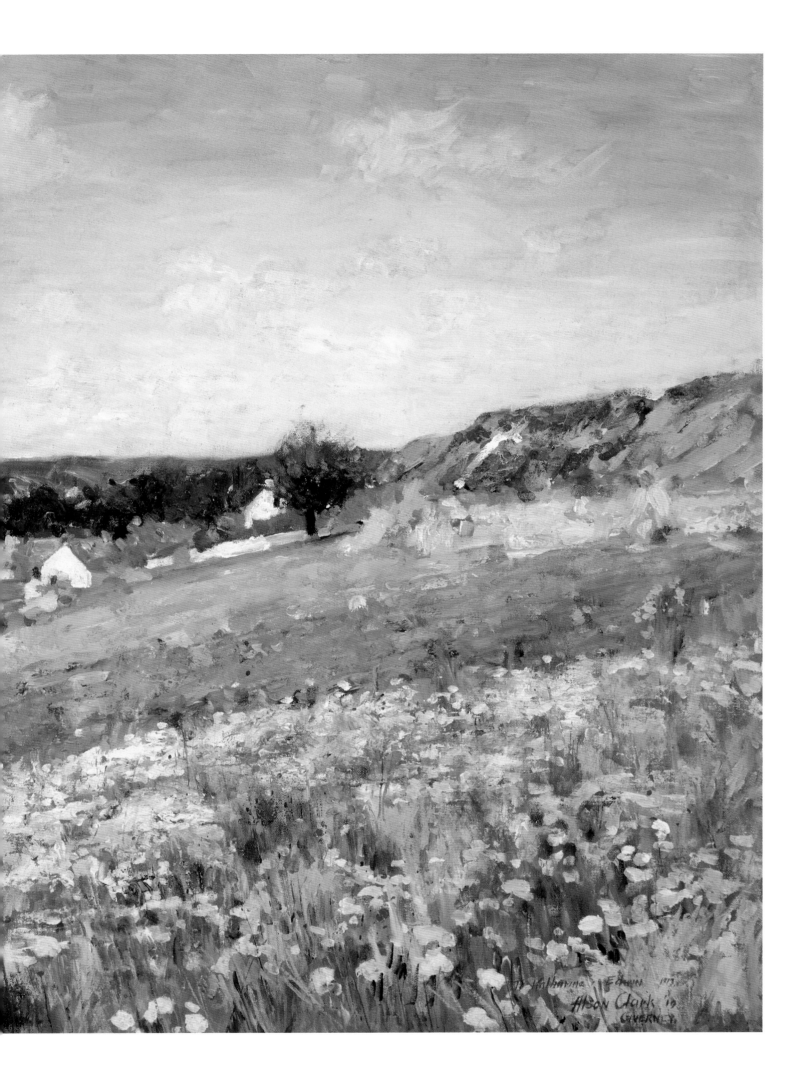

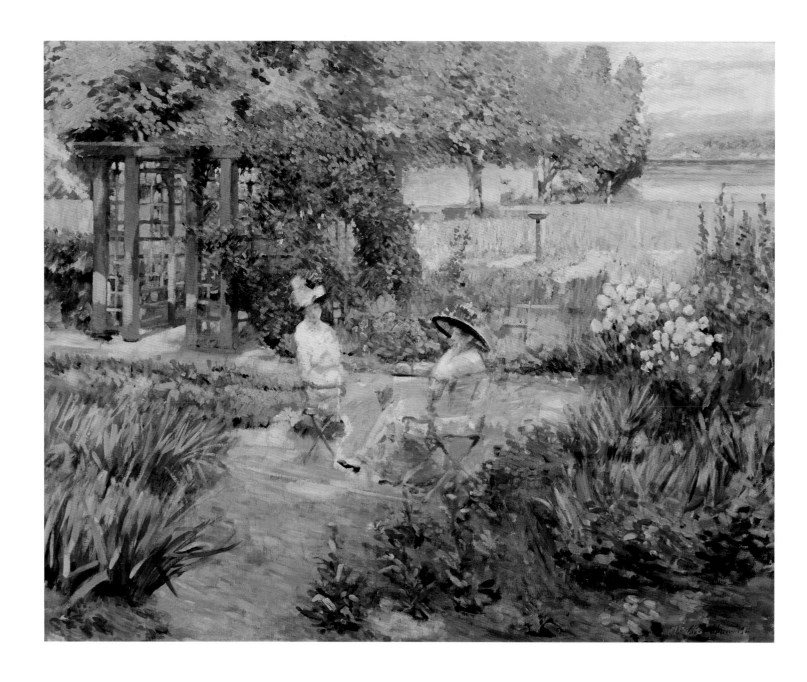

PLATE 23

In the Garden, 1910

Oil on canvas, 30×40 inches
Edwin H. Clark Estate

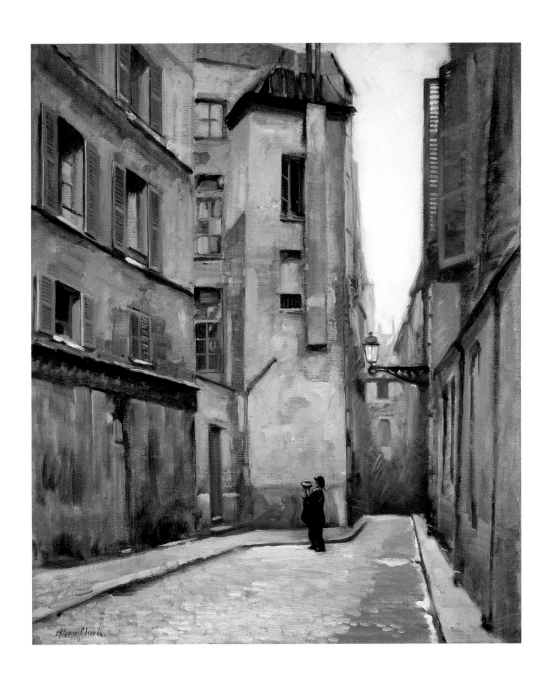

PLATE 24

Paris, c. 1910

Oil on canvas, 25×21 inches
DeRu's Fine Arts, Laguna Beach, California

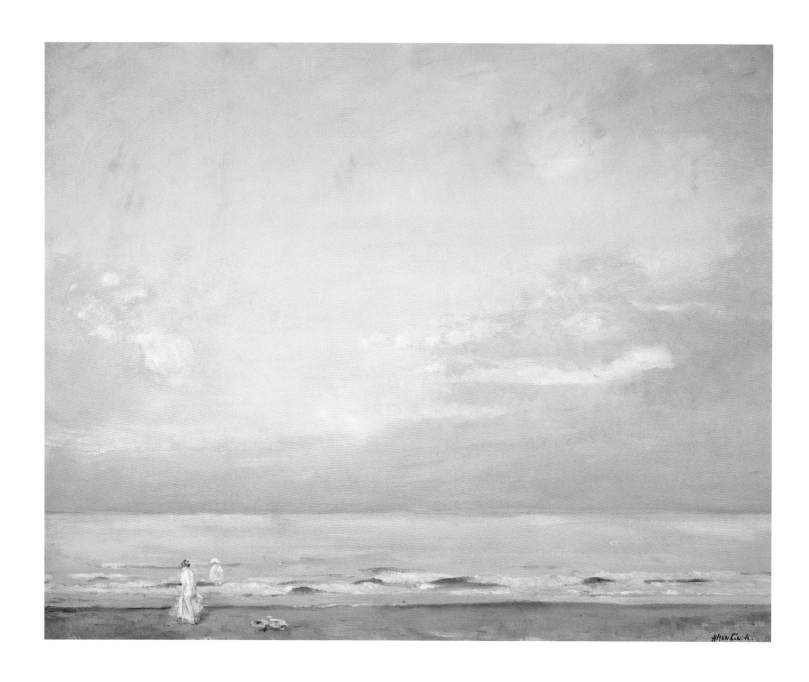

PLATE 25

Sunset, Normandy, c. 1910

Oil on canvas, 26×32 inches
Collection of Paul and Kathleen Bagley

yellow, a swirl of pastel clouds expands across the horizon. Purple shadows and highlights, typically favored by Impressionists, are carefully placed.

Clark's slow but not exclusive stylistic move toward Impressionism is evident throughout the first decade of the century. References to Whistler and a tonal palette gradually became less frequent during this transition. Despite their being invited to Giverny in August 1910, Clark's conversion to Impressionism remained slow and partial, as he maintained a lingering devotion to Whistlerian strategies. However, as he worked among the American Impressionists in Giverny, Clark's palette brightened even further, he focused on fugitive and prismatic light, and he began to apply paint more broadly.

The American art colony in Giverny has been the subject of various studies, and most thoroughly examined by William H. Gerdts.[81] Attracted initially by the presence of Monet, who moved there in 1883, several generations of American painters became summer or year-round residents of the small village. Although Monet did not fraternize with most of the Americans, he did have a close relationship with Theodore Robinson and Theodore Butler (who married Monet's stepdaughter, Suzanne Hoschedé).

The first generation of American painters in Giverny included Robinson, Butler, John Leslie Breck, Lilla Cabot Perry, and Willard Metcalf. These artists focused mostly on landscapes and gathered at the Hôtel Baudy (established in 1887). By late 1910, when the Clarks arrived in Giverny (at the invitation of Lawton Parker and his wife), a third generation of Americans was in attendance, including their friends Parker and Frieseke, Edmund Graecen, Richard Miller, Guy Rose, and others. Most of this group knew one another from Chicago or from

Paris. This circle of painters is noted for portraying women in a highly decorative Impressionist style.[82] They depicted each other's wives and children posed in landscape settings, drinking tea, and walking in the gardens; they hired models for their renderings of the female reclining nude. Frieseke, Rose, Parker, Graecen, Miller, and Karl Anderson exhibited together in 1910 at the Madison Gallery in New York, eventually adopting the epithet "The Giverny Group." As the American community was exceptionally tight-knit, social activities were nearly as important as painting. Weather permitting, the artists often painted side by side.

Very few of Clark's Giverny works have surfaced. Interestingly, no figurative works are known, and specifically no nudes—a predominant theme for Parker and Frieseke. Clark's note cards document a number of landscapes, such as *In the Valley of the Seine* and *The Banners of Autumn, Giverny* (both unlocated). Black-and-white reproductions include examples of haystacks, Medora even referring to one of his works as a "Monet haystack."[83] One of the best extant examples from this period is *Summer, Giverny* (plate 22). As Gerdts has observed, the composition is strikingly similar to Theodore Robinson's *A Bird's-Eye View* (1889, The Metropolitan Museum of Art, New York). Clark used dots of color to create the wildflowers in the foreground and economic brushstrokes for the houses and hillsides in the background. Carefully positioned dabs of color—red, lavender, and yellow—provide accents. This painting represents a culmination of Clark's move toward Impressionism.

The Clarks left Giverny in late August but returned for another visit in October. Life in Giverny had its own challenges. Prices for everything from food to real estate were inflated.[84] And, figuratively speak-

PLATE 26

Thousand Islands, New York, 1911

Oil on canvas, 25×31 inches

Private Collection

ing, the American community was highly incestuous. They lived, painted, played, and argued all within full sight of each other. Ultimately, Medora did not find it a convivial atmosphere: "The more I reflect on the possibilities of Giverny as a place to go, the less I care for it. The petty jealousies . . . the fights, the spying on you by your neighbors all works up to the least attractive place . . . to spend a season. Then the similarity in all of the work. I have kept out of it."[85] Whether or not Clark shared his wife's feelings, this was the last significant amount of time that the couple spent in Giverny.

In February 1911, Clark had an exhibition of his Normandy scenes at O'Brien Art Galleries. He was aware that the tenor of this work was substantially different from the upbeat and colorful Spanish paintings that had recently sold so well, but he was determined to produce another show. From the outset, it was clear that the Normandy work did not have sufficient commercial appeal. Disappointed but not discouraged, he decided that a change of scenery was in order; in May he left for New Orleans to visit family and see the city.

During that summer on Comfort Island, Clark produced several brilliantly prismatic Impressionist depictions of the area. *Thousand Islands, New York* (plate 26) illustrates the vegetation and river. While Clark never dissolved the structure and integrity of his forms, here the water is rendered in large blocky brushstrokes similar to, for example, Auguste Renoir's depiction of water in *La Grenouillère* (1869, National Museum, Stockholm). Reflections, created in part through the careful juxtaposition of colors, are masterfully rendered.

In the fall, the Clarks returned to Paris, where Alson became acquainted with the Czech artist François

Simon,[86] who invited him to come along on a visit to Prague in January. Clark found Prague eminently paintable, if a bit cold. "This morning I went out to paint for the first time and had a bully time. . . . We went down to the river and I did a sketch of the old bridge in the haze and sunlight. It was very cold, so I staid [sic] less than an hour." He may well have been referring to *Charles Bridge, Prague* (plate 27), a small sketch obviously produced quickly and on the spot. Clark made several freely painted, fairly tonal small sketches of the city. Through Simon, he had access to Czech artists:

> I had quite a discussion with a bunch of Cubists the other night. . . . They are quite a fuzzy bunch of mad artists, Cubists, Expressionists, etc. . . . It seems they draw that way purposely (odd) and also that is so much expressive of feelings than it could otherwise be (must have eaten something indigestible). The color is not really necessary (fine). There isn't anything such as "correct drawing," everyone sees it differently (think how strange the world must look to a Cubist).[87]

Despite being exposed to the most modern trends in Paris, Clark had not previously expressed in writing his ideas regarding the various "ists" and "isms." Clearly he was disparaging of avant-garde art and its theoretical basis.

After returning from Prague, Clark announced plans to visit Dalmatia in the spring. Now part of Croatia, Dalmatia lay within the Austro-Hungarian Empire. Aside from the artists Martha Walter and Alice Schille, who visited Dalmatia in 1909, very few Americans had ventured there.[88] The Clarks' first stop was the port of Zara (now Zadar), then on to Sebenico (Sibenik), and finally to Spalato (Split). Spalato was a major center; Clark was overwhelmed

by the variety of costumes, people, and wares in the almost daily open air markets. *Bazaar, Spalato* (plate 32), a brilliantly composed depiction of the city life, includes the poignant touch of a woman in the foreground looking over her shoulder at the viewer—acknowledging our glimpse into this fairly isolated world.

Clark was prolific during this period. He organized a show of twenty-four Dalmatia paintings at O'Brien's in 1913. Given the tepid response to his Normandy pictures, he was determined to mount a successful exhibition. The critics bubbled with enthusiasm, erasing the earlier disappointment. Harriet Monroe wrote a glowing appraisal of the exhibition and described Clark as "rapidly becoming a brilliant painter," who has "painted with manifest enthusiasm everything he saw. . . . " Specifically referring to *Bazaar, Spalato,* she observed: "the brightly colored costumed figures are handled as skillfully as an operatic chorus, with old red roofed houses for the orchestra and the blue sky for the star's soprano voice above them. Indeed this is an operatic region and these pictures are full of lyric suggestion."[89]

It is debatable whether or not Clark's choice of exotic locales was a conscious effort to please the critics, who were often hungry for new imagery, or was part of an overall strategy to sell his pictures. To be sure, Clark wanted and needed commercial success. However, no evidence suggests that the locations he traveled to and painted were chosen for anything more than to satisfy his own desire for new sources, hoping that his own enthusiasm would evoke equally favorable reactions from the critics and collectors.

PLATE 27

Charles Bridge, Prague, 1912

Oil on board, 7½ × 9½ inches
Private Collection

PLATE 28

Over the City, Prague, 1912

Oil on board, 7½ × 9½ inches
Private Collection

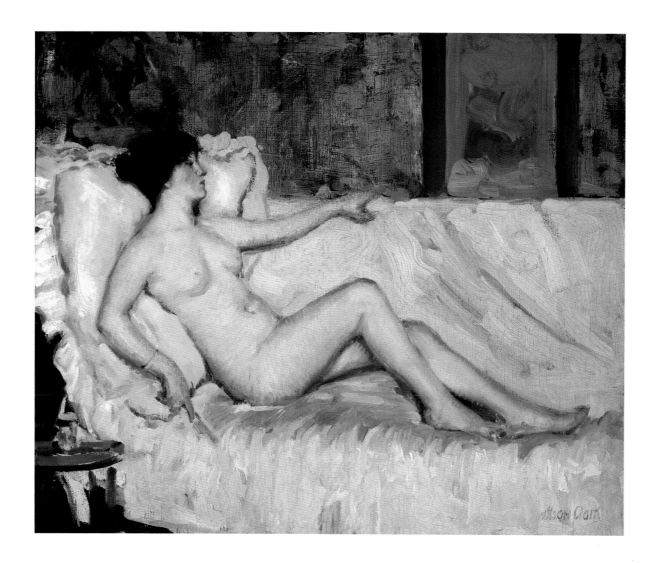

PLATE 29

Reclining Nude, 1912

Oil on canvas board, 15×18 inches
The Redfern Gallery, Laguna Beach, California

PLATE 30

Rue St. Jacques, 1912

Oil on canvas, 21½ × 25½ inches

Private Collection

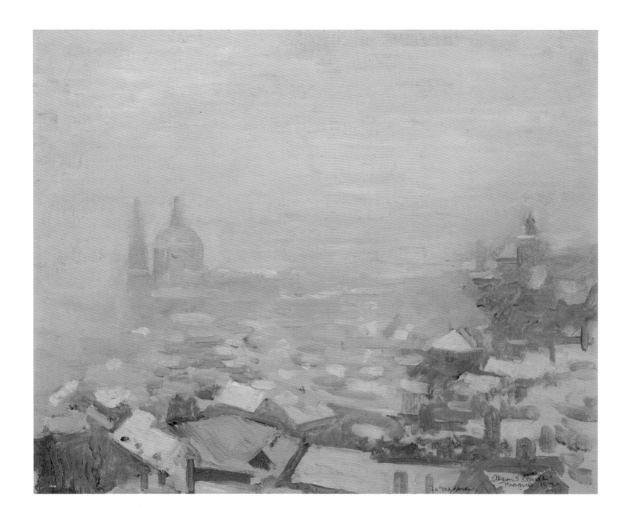

PLATE 31

Snow over Prague, 1912

Oil on board, 7×9 inches
Private Collection

PLATE 32

Bazaar, Spalato, c. 1912

Oil on canvas, 38×48 inches
Collection of Pasadena Public Library, California

The Panama Canal

In March 1913, the Clarks decided to visit the Panama Canal Zone to view the waterway under construction. The trip was one of the highlights of their lives. The thousands of tourists visiting the area necessitated special guides and trains, and, according to one observer, "the groups looked no different from the Sunday crowds on the Board-walk at Atlantic City. Gentlemen wore white shoes and pale straw hats; ladies stepped along over the grass in ankle length skirts and carried small, white umbrellas. . . ."[90] Despite this civilized picture, the magnitude of the canal project—and its attendant problems—cannot be overstated. David McCullough, author of the most exhaustive study of the canal's construction, offered this observation:

> The creation of the Panama Canal was far more than a vast, unprecedented feat of engineering. It was a profoundly historic event and a sweeping human drama not unlike that of war. Apart from wars, it represented the largest, most costly single effort ever before mounted anywhere on earth. . . . Great reputations were made and destroyed. For numbers of men and women it was the adventure of a lifetime.[91]

The details and statistics regarding this project are nothing short of astounding. The initial French attempts at construction, spearheaded at one point by Ferdinand-Marie de Lesseps, builder of the Suez Canal, were unsuccessful; the loss of life from both accident and disease was appalling.[92] The canal became a focal point of Theodore Roosevelt's presidency, as he successfully supported a "revolution" of sorts to help create an independent Republic of Panama—and immediately drafted a treaty in 1903 that granted a concession to the United States for the Canal Zone. American construction officially began in 1904. Faced with the same obstacles that had stymied the French, the Americans did manage to get malaria and yellow fever under control, considerably reducing the death rate.

Although the Clarks left precipitously for Panama, Alson was able to contact and persuade the current supreme commander of the project, Colonel George Goethals, to allow him access to the construction sites.[93] Clark wrote to his mother:

> This is such a busy place for me I never get time to write more than a postal. We get off on the 6:40 train in the morning, getting up at five-thirty or so and get back at noon, leave for lunch and go off again at one-thirty, getting in at seven and after dinner go to bed. . . . In the afternoon at present I go to the Culebra Cut where all the blasting has been going on and the slides, and I paint there. It is wonderful all over. . . . [94]

Clark's output in Panama was astounding. He painted the locks, the various cuts, lock chambers, cranes, slides, and the railroad. And, interestingly enough, these works vary stylistically from highly Impressionist to more tightly constructed and defined.

To understand what these paintings represent, it is necessary to have a rudimentary notion of how the canal works. Once a decision was made to build a lock (instead of a sea-level) canal, a dam was constructed at Gatun to fuel the locks, creating what was then the largest artificial lake in the world. Three locks (or pairs of chambers) at Gatun raised or lowered ships eighty-five feet vertically. Another set of locks was placed on the Pacific side at Pedro Miguel, and two sets in Miraflores—in all, twelve chambers. Water flowed in and out of the locks through culverts or drains in the walls of the locks.

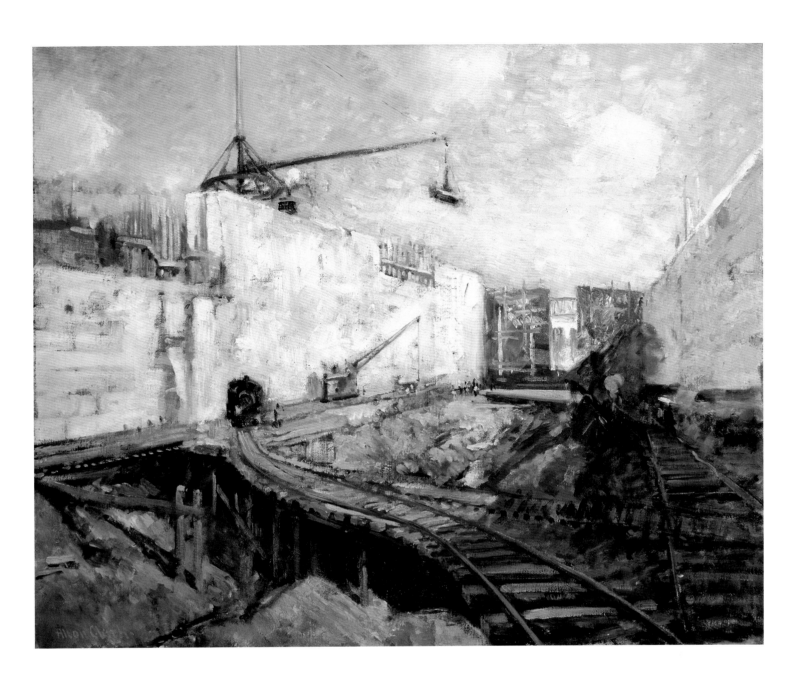

PLATE 33

In the Lock, 1913

Oil on canvas, 25 × 31 inches
Collection of W. Donald Head/Old Grandview Ranch

PLATE 34

Panama Canal, The Gaillard Cut (originally titled *The Culebra Cut)*, 1913

Oil on canvas, 21×22½ inches

The Delman Collection, San Francisco

PLATE 35

Panama City, 1913

Oil on canvas, 21½ × 25½ inches

Collection of Paul and Kathleen Bagley

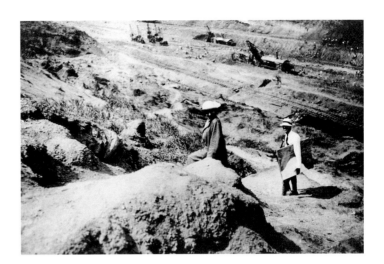

Alson and Medora Clark in The
Culebra Cut, Panama Canal, 1913
Collection Jean Stern, The Estate
of Alson Clark

Each chamber was closed at both ends with steel gates. The critical element, of course, was the flow of water, which lifted ships above sea level to the surface of the Gatun Lake, floated them across the Continental Divide, and deposited them in the opposite ocean.

The locks were the engineering and structural marvels of the canal and their scale was Herculean; the walls were one thousand feet long and eighty-one feet high. They required the installation of four and one-half million cubic yards of concrete, ninety-two steel gates, hundreds of valves, and fifteen hundred electric motors to regulate the movement of the water.[95]

The enormity of this undertaking is highlighted in works such as *In the Lock, Pedro Miguel Locks,* and *First Dredges through the Gatun Locks* (cat. nos. 33, 36, and 38). The paintings focus on the cavernous space of the locks; the inclusion of workers establishes the scale. In reality, a single lock placed on its end would have been the tallest structure in the world at that time.[96] That Clark would even attempt the challenge of depicting these behemoths is a testament to his resolve. Impressionist techniques of divided color and sketchy brushwork dominate passages, but there is a simultaneous adherence to line and form. The handling of paint adds visual appeal but does not obscure the subject.

The Panama Railroad was the lifeline of the project. Although the French had built a rail infrastructure, American engineers found it inadequate. In 1905 John Stevens assumed the post of chief engineer, and under his direction the railroad was completely refurbished. Virtually all canal construction was associated with the railroad. Its central role is demonstrated in two closely aligned paintings, *Work at Miraflores* and *In the Lock, Miraflores* (cat. nos. 37 and 40), in which the viewer looks down into the construction pit at the railroad cars that spew smoke. Clark's debt to Impressionism is clear in his staccato brushwork and shorthand notation, lavender shadows, and saturation of light. In particular, the puffy clouds of smoke are merely suggested by dabs of white, blue, and pink—overt references to Monet's pictures of trains at the Gare St.-Lazare.

While the locks were engineering marvels, the magnum opus of the canal was the excavation at Culebra, a nine-mile stretch between Bas Opiso and Pedro Miguel; it was also the site of some of the worst slides during the construction between 1907 and 1913. Medora offered her observations of the Culebra Cut:

> To appreciate the Culebra Cut, which is the key to the whole place, to understand the activity, the energy, the push, the absolute defiance of nature in undertaking the enterprise, and to sense its spirit, it is necessary to tramp through it, and this not once, but many times.[97]

Clark painted Culebra in various iterations, including *Panama Canal, The Gaillard Cut* (originally titled *The Culebra Cut*) (plate 34). Rendered in high-key colors with aggressive brushwork, the composition is an intricate assemblage of patterns. The bold execution speaks to the intensity of the subject—a massive undertaking that pitted the forces of nature against the tenacity of the human spirit.

PLATE 36

Pedro Miguel Locks, c. 1913

Oil on canvas, 38×50 inches
The Buck Collection, Laguna Hills, California

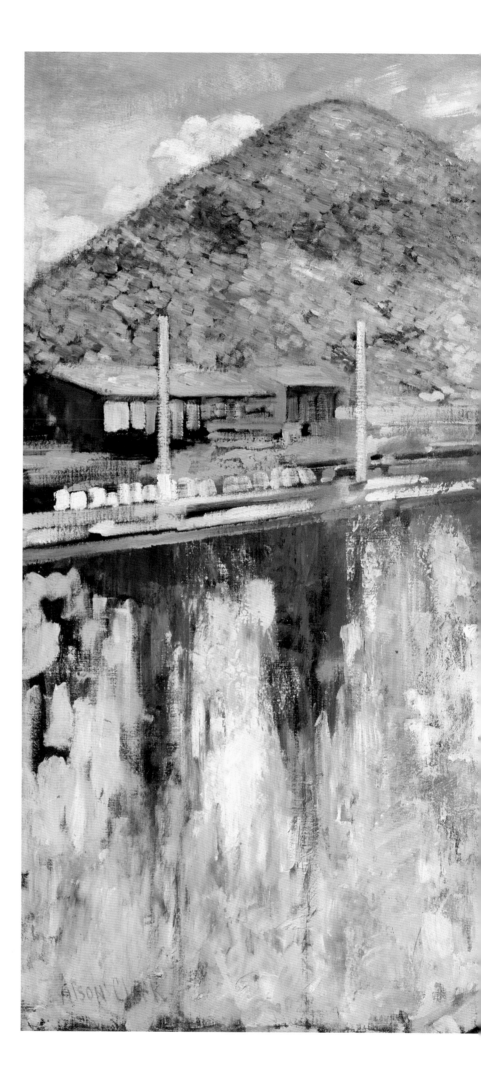

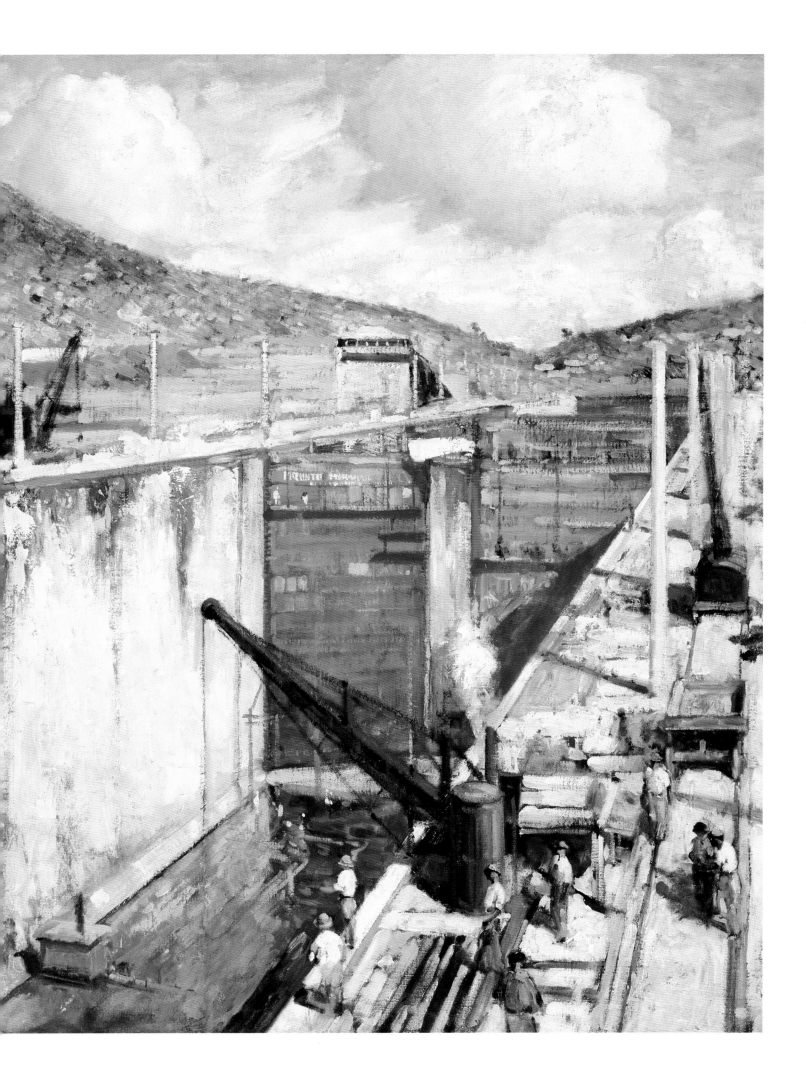

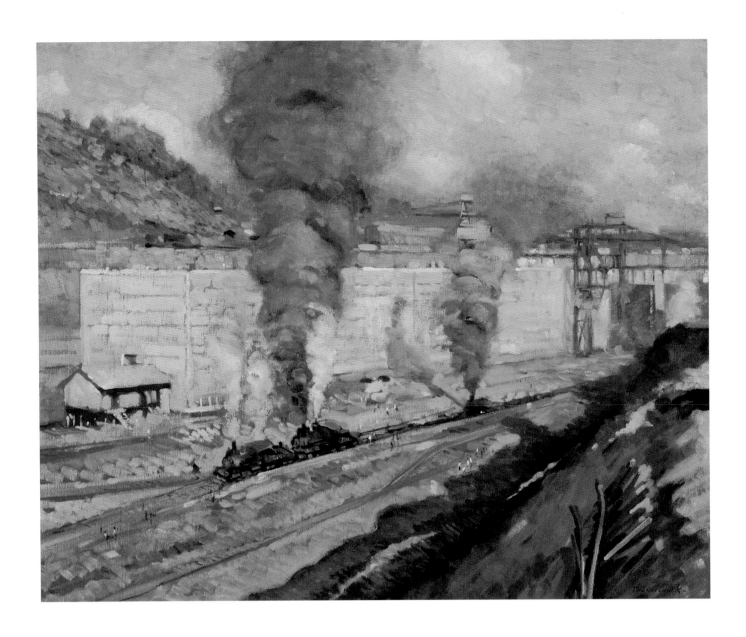

PLATE 37

Work at Miraflores, c. 1913

Oil on canvas, 25½ × 31½ inches
Private Collection
Photo courtesy of The Redfern Gallery, Laguna Beach, California

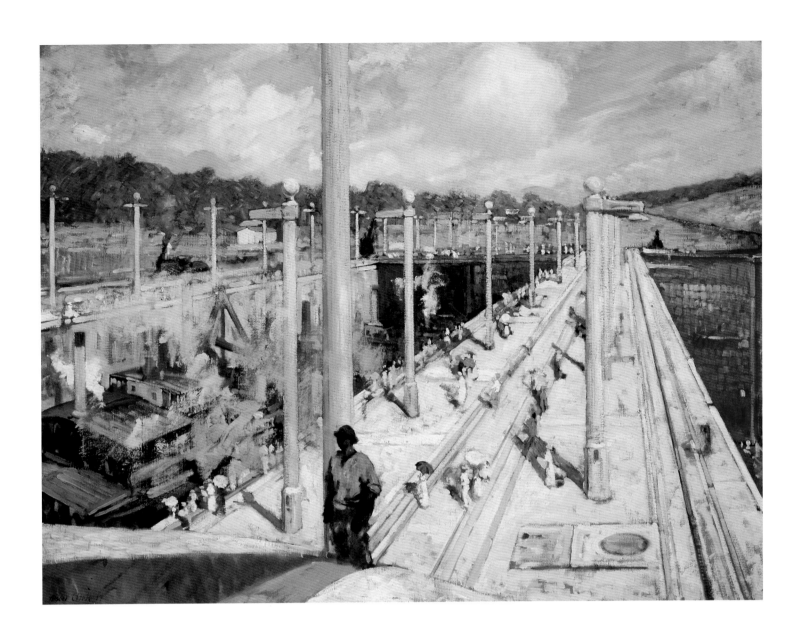

PLATE 38

First Dredges through the Gatun Locks, 1914

Oil on canvas, 38×50 inches
Collection of Brad Freeman and Ron Spogli

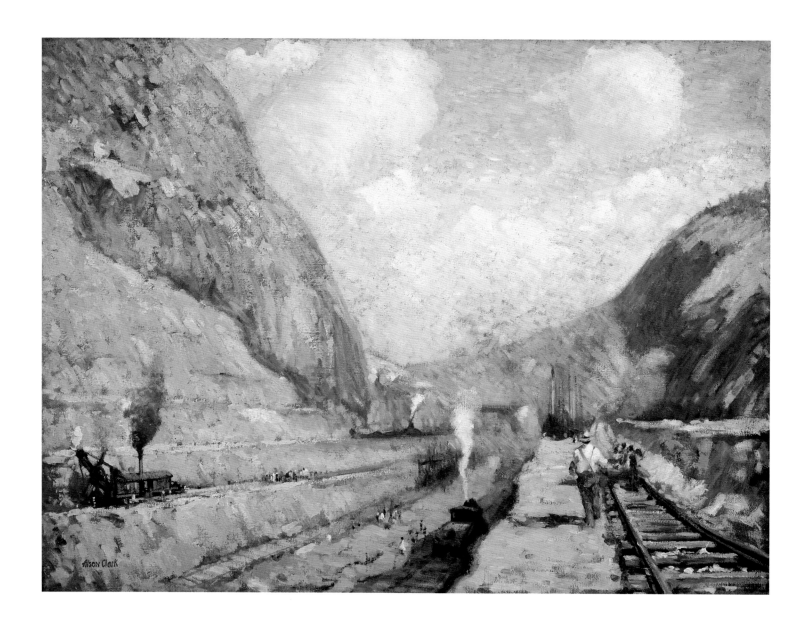

PLATE 39

In the Cut, Contractors Hill, c. 1914

Oil on canvas, 37½ × 51½ inches
Collection of Brent and Carol Gross

Aside from painting the construction, Clark depicted the surroundings in works such as *Panama City* (plate 35). He focused his enduring interest in architecture and costumes on the homes and clothing of the West Indian workers.[98]

In general, Clark's scenes of the canal's construction bespeak the optimism of American ingenuity. They reinforce both the real and perceived imperative of this undertaking but completely ignore the human toll extracted during the epic enterprise. Although workers were routinely injured or killed through accident or disease, none of the paintings addresses the hazardous conditions. Clark focused solely on the engineering feats and organizational extent of the project.

Although his efforts were prodigious, dwindling supplies and the onset of the rainy season precipitated the couple's decision to spend the summer in France and return to Panama in September to see the center of the dyke destroyed and the flooding of the cut.[99] Their return to Panama was a kind of "homecoming," Medora describing their inclusion "in all the ceremonies with as much courtesy and consideration as though we, too, had been a part of the work. It was exciting to be present at the culmination of the vast project. . . ."[100]

In June 1913, Clark contacted John Trask, Director of Fine Arts for the forthcoming 1915 Panama-Pacific International Exposition in San Francisco, sending a letter with a few photographs of works he had produced in the Canal Zone. Although the letter is not extant, it appears from Trask's response that Clark suggested that a significant number of his Panama paintings be exhibited as a group at the exposition. An admirer of Clark's work, Trask responded positively, while acknowledging that

"the giving of the gallery to you is going to arouse criticism on the part of the many who would be glad to have galleries for their own work but who will not get what they want." He further noted that "while I cannot but recognize, as you will, that in giving a gallery to you the Fine Arts Department is, in a way, bestowing an honor upon you. I feel it is a worthy bestowal and I do recognize the unselfish attitude you have assumed in regard to the exhibition."[101]

No evidence suggests that Clark's initial impetus for painting the canal was the hope of such an in-depth solo exhibition. That said, once Clark was satisfied with the quality of his Panamanian pictures, he viewed the celebratory images as appropriate to the exposition's focus and recognized the potential professional opportunity. The Panama-Pacific Exposition was a historical landmark in signaling the phoenixlike resurgence of the city of San Francisco and in the ambitiousness of its pictorial and architectural programs.[102] In receiving his own room, Clark joined luminaries similarly honored at the exposition, such as Whistler, Chase, Frank Duveneck, Childe Hassam, Edmund Tarbell, John Twachtman, and John Singer Sargent—some of the most respected artists of the period.

Clark's agreement with Trask allowed him to exhibit the Panama paintings prior to the exposition. Three paintings were included in the annual exhibition at The Art Institute of Chicago in fall 1913, and thirty-one were shown at O'Brien Art Galleries in Chicago in late November.[103] The critics were laudatory: "we who have not seen Panama and have heard but the echoes of the marvelous work are impressed by the awesomeness and are, for an instant, transported into the steamy atmosphere and the blaze of midday sun."[104]

Twenty-six of the paintings shown in Chicago were exhibited in January 1914 at the prestigious Vose Galleries in Boston. The press response was encouraging: "In Alson Skinner Clark's series of twenty-six oil paintings of Panama, the paintable qualities of the Canal Zone are made more than ever obvious. . . . Mr. Clark is an excellent painter. . . . "[105] At their next stop, at the Toledo Museum of Art, Ohio, in 1914, the works were greeted with similar enthusiasm.

Following the Chicago opening, Clark had returned to Paris to work on new paintings for the exposition. He labored feverishly that spring and decided to take a summer holiday traveling through France with the "humpmobile" (a rudimentary automobile) purchased the previous fall; the couple was accompanied by Medora's sister. Amazingly unaware that Europe was on the brink of war, Clark expressed his naïveté regarding the gravity of the situation in a letter to his mother:

> The police came down the street on the run to the mayor's house to tell him they had received the news of the mobilization. . . . You see, prices will go up terribly in Pairs, and it will be almost impossible to stay there while we are perfectly safe. . . . Perhaps when you get this all will have blown over and there will not be anything to worry about.[106]

This disbelief or denial had practical ramifications. Upon their return to Paris, the Clarks were faced with the conundrum of getting themselves—and the large Panama pictures—to America. Having determined that the pictures could not be shipped by freight, they secured passage on a ship, rolled the massive canvases, and carried them as luggage—an ordeal that speaks to their determination not to abandon Alson's important work.[107]

The prelude to the Panama-Pacific International Exposition boded well for Clark's reception at the exposition itself. The unexpected death of Sarah Clark in February 1915 precluded any travel plans for the opening or the immediate future. As promised, eighteen of Clark's paintings were hung together in gallery number seventy-three.[108] *In The Lock, Miraflores* was awarded a bronze medal, and public response was encouraging. However, the critical reaction in San Francisco was less sanguine. The most acerbic commentary came from Eugen Neuhaus, a painter and the head of the Department of Art at the University of California, Berkeley. Neuhaus served on the International Jury of Awards, and his in-depth review of the paintings, *The Galleries of the Exposition,* was highly dismissive of Clark's efforts: "Alson Skinner Clark has been given the privilege of almost an entire gallery, without any other justification than historical interest in his shallow Panama scenes."[109]

In the absence of any documentation, we can only surmise that Clark was surprised and unsettled by this vitriolic assessment. Nonetheless, he brought the same works to Chicago for an exhibition at the Art Institute in September 1916. The critical reception could not have been more dissimilar. The *Chicago Evening Post* described them as "splendid . . . and so with a sense of their importance one should take the unjaded interest at the opening of the season . . . to revel in the color and romance of the great undertaking as pictured by Mr. Clark." The *Chicago Tribune* was even more resolute: "No one should miss this historic group."[110]

In the aggregate, the Panama pictures were a critical success but not a financial windfall. It appears that Clark painted at least forty Panama scenes (including those not specifically of the construction) and divided the works into two groups: those shown

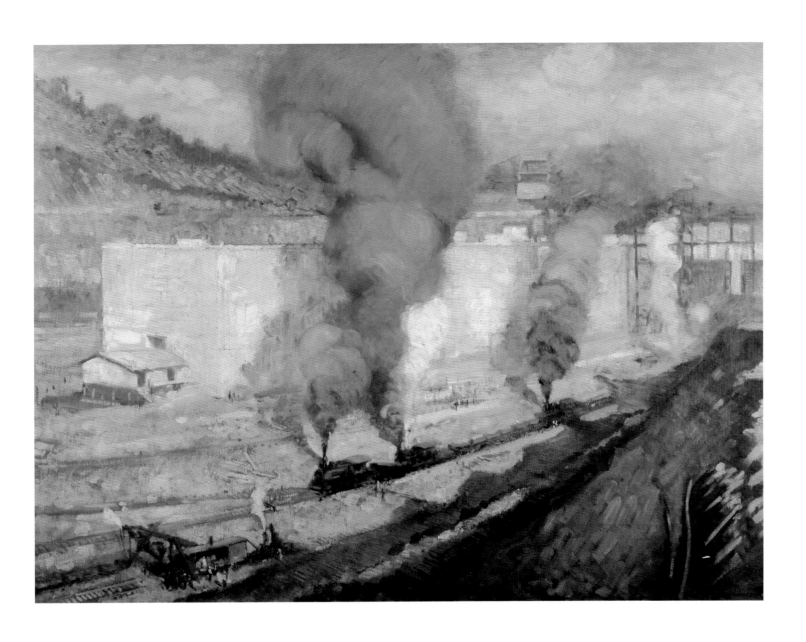

PLATE 40

In the Lock, Miraflores, c. 1914

Oil on canvas, 38½ × 51¼ inches

Collection of Jason Schoen, Miami

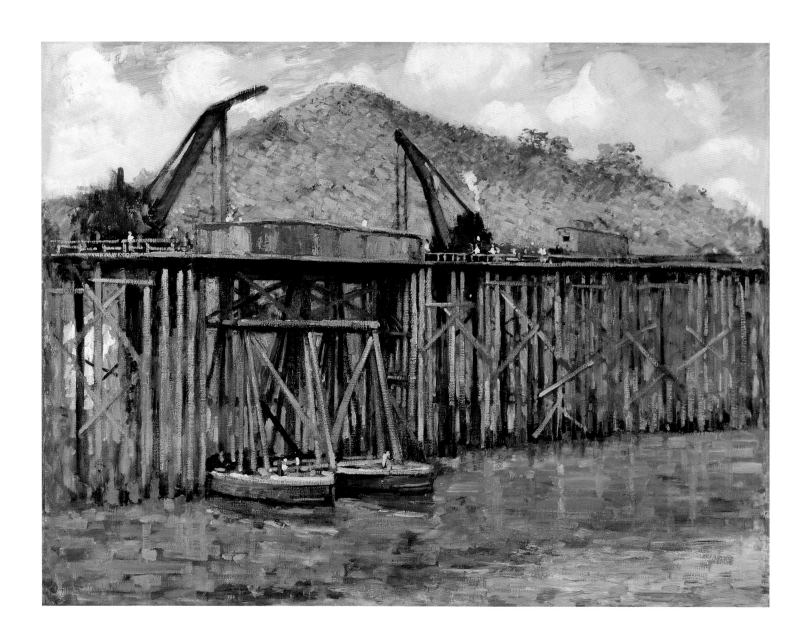

PLATE 41

Moving the Trestles, c. 1914

Oil on canvas, 35×46 inches

Collection of Paul and Kathleen Bagley

prior to the exposition and those specific to the exposition and then later re-exhibited together at The Art Institute of Chicago in 1916. It is not known whether Clark hoped the latter group would remain intact, but he pragmatically expressed his desire to sell the works individually.

To have undertaken the challenge of painting the canal was charting completely new territory. Two particular artists preceded Clark in Panama: Jonas Lie and Joseph Pennell. Medora's correspondence suggests that Lie and Clark overlapped there for a short period at the end of March 1913.[111] Lie created a series of large, skillful, highly Impressionist canvases that were critically appreciated.[112] Pennell preceded both Clark and Lie in the Canal Zone, arriving in January 1912. The results of that trip were twenty-eight lithographs of the construction and descriptions of Panama City, which were included in two books from 1912, *Pictures of the Panama Canal* and *Pictures of the Wonder of Work*.[113] The optimism of the canal project is first evident in Pennell's works, in which steam shovels, cranes, and trains all work in concert. Pennell's spirit of accomplishment was taken up by his successors.

The formidable canal pictures established Clark as a fully mature artist with national and international recognition. His commitment to Impressionism was solidified, albeit, as with so many Americans, practiced in a modified version. Line, drawing, and structure were never abandoned but integrated with fugitive light, daring color, and bold brushwork. Painting the Canal Zone forced Clark to test the boundaries of his skill. He had never attempted a "series" and was certainly a novice with a project of this magnitude. Panama represented a crucible of sorts, and Clark passed this difficult test with distinction.

The Great War

With World War I raging in Europe, the Clarks remained in the United States, spending the spring and summer of 1915 at Comfort Island, where Alson constructed a new studio. That fall they accepted an offer to visit Charles and Edith Bittinger, friends from the early days in Paris, at their home in Duxbury, Massachusetts.

Clark again found infinite possibilities in the winter landscape; his notebooks confirm that he produced a number of works in Duxbury. Not wishing to unduly impose on the Bittingers, the couple rented a room at an inn in Jackson, New Hampshire, where Clark painted *en plein air,* using the snowshoes that had served him so well in Quebec. One of his most successful works is *Frozen River, Jackson, New Hampshire* (plate 43). Cool colors dominate, with purple and blue shadows reflecting off the white snow. Small areas of water on the mostly frozen river reflect brown hues from the trees in the background. A fire at their lodging interrupted the Clarks' peaceful stay in New England, destroying the inn but sparing all lives; Clark managed to save his easel, paint boxes, and most of his canvases (at the expense of nearly all of their clothing).

The remainder of 1916 was spent alternatively at Comfort Island and in Chicago. The Clarks left Chicago with friends in late January or early February 1917 for a trip to Charleston, South Carolina. Aside from a brief stay in New Orleans, the South was new territory for the Clarks. In her study of the Charleston Renaissance, Martha Severens has noted that by the early twentieth century the city was attempting to establish itself as a cultural destination for Northerners.[114] Charleston had character and history, despite the devastation of the Civil War, and its decline and rebirth were omnipresent in its streets and buildings.

Charleston's "old houses, the iron work, the balconies, the massive gates, the church spires, and the beautiful walls gave promise of infinite motifs."[115] In fact, the Clarks remained in Charleston long after their friends departed, settling in a pleasant but aging boardinghouse, "The Matthews House," whose owner, Miss Matthews, rented her front chamber. Clark immediately began to paint.

One particular motif favored by both local and visiting artists was the church of St. Michael's. The landmark was so popular in nineteenth-century engravings and picture postcards of the city that by the early twentieth century it was an icon. The church was painted, for example, by Birge Harrison in 1919 (*St. Michael's,* The Butler Institute of American Art, Youngstown, Ohio) and drawn by Childe Hassam in 1925 (*St. Michael's,* The Fogg Art Museum, Harvard University Art Museums, Cambridge, Massachusetts). Clark painted several iterations of the church, including *St. Michael's, Charleston,* 1918 (Collection of Dr. Mark G. Wood).

Part of Charleston's attraction was in its architectural diversity, its "dynamic interplay of high style and vernacular."[116] Among the most popular vernacular buildings was a three-story tenement complex known as Cabbage Row (given the epithet because of the vegetable merchants who sold daily offerings on the street) or Catfish Row, immortalized by DuBose Heyward in his 1925 novel *Porgy.*[117]

The dilapidated row of eighteenth-century houses provided Clark with perfect material. His paintings *Catfish Row* (also known as *Cabbage Row*) and *Catfish Row, South Carolina* (cat. nos. 45 and 44) present two different vistas: the former, a truncated view of the derelict row houses, and the latter, a freestanding structure with three figures. In both paintings, the

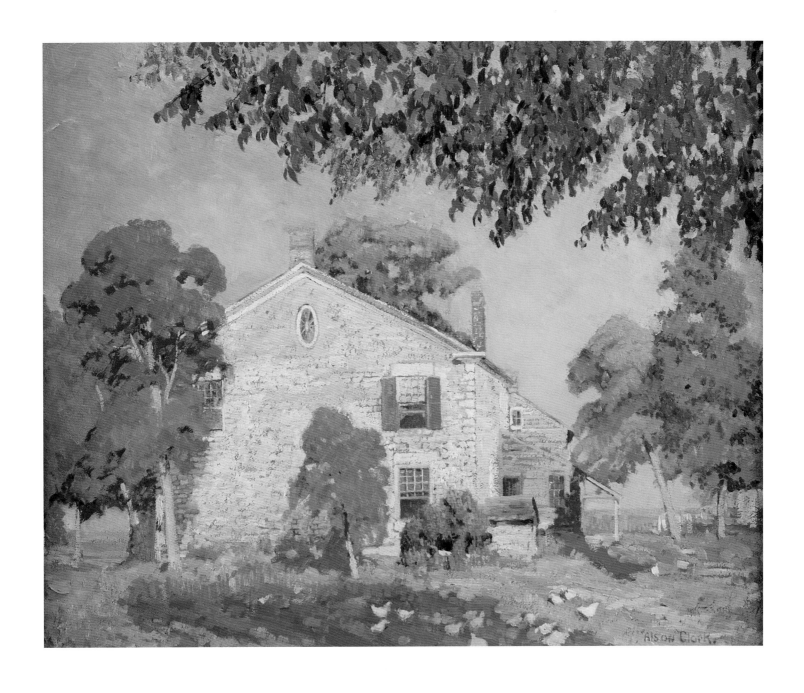

PLATE 42

Windy Hill Farm, Thousand Islands, Alexandria Bay, 1916

Oil on canvas, 26×32 inches

Collection of Ranney and Priscilla Draper

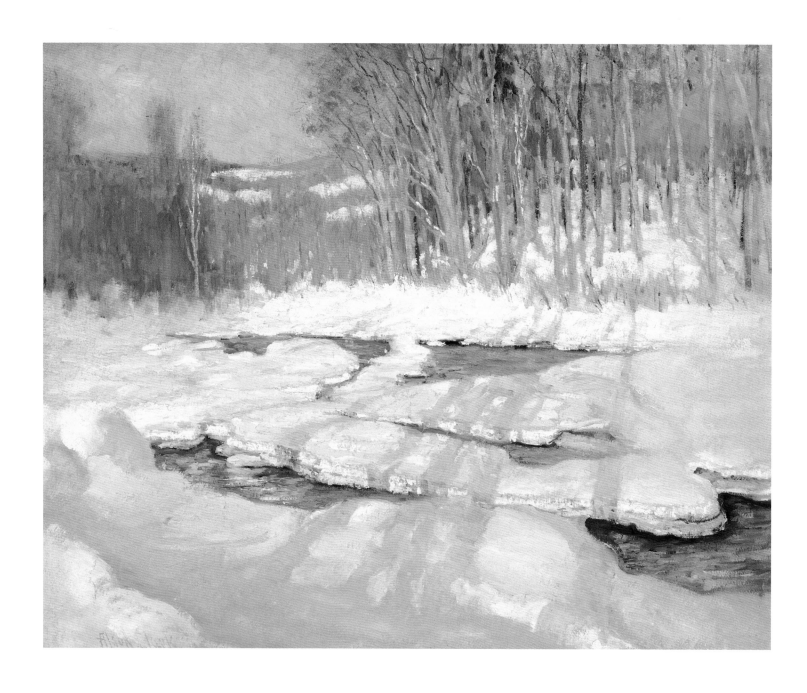

PLATE 43

Frozen River, Jackson, New Hampshire, c. 1916

Oil on canvas, 25×31 inches
Collection of Paul and Kathleen Bagley

U.S. Navy F2A flying boat,
1917–18
Collection Jean Stern,
The Estate of Alson Clark

faded and discolored brick buildings offered varia-
tions of color, light, and shadow. Chipped wood
shutters badly in need of a fresh coat of paint cover
the windows. Lavender shadows predominate,
and, in now typical fashion, Clark has incorporated
both carefully described and loosely rendered
passages. Significantly, the artist's fascination with
aging and crumbling structures—not just architec-
ture but actual deterioration—emerges in earnest
at this juncture and culminates in his paintings in
California and Mexico.

While the skeptical locals were cordial toward the
newcomers, the affable Clarks managed to win
many hearts during their stay. Even their slightly
cranky landlady who "gave no board" would occa-
sionally offer the couple a home-cooked meal.
Clark memorialized the wonderfully aged exterior
of that kitchen in *Miss Matthew's Kitchen* (plate 48).

The tranquility of the Charleston interlude was
shattered when the United States entered World
War I on April 6, 1917; the Clarks abruptly left for
Chicago. Although Clark was not a candidate for
conscription, he believed that his fluency in French
and familiarity with the French countryside could
benefit the military. He enlisted in the Navy and in
November was sent to France to serve as an
interpreter.[118]

Arriving in Paris, Clark was disappointed to learn
that his language skills were not compatible with
the Navy's needs. However, a position as a clerical
personnel manager responsible for the identification
photos of soldiers needed to be filled. An accom-
plished photographer (he had built his own dark-
room at Comfort Island), Clark was given the
assignment. By March 1918, he had been promoted
to "official photographer."[119] His duties were once

again augmented in May 1918 when he was sent to
London to train as an aerial photographer—a job
that literally entailed hanging out of an open plane
(an F2A flying boat) while taking photographs.
Medora recalled that "fly-boy" pilots who enjoyed
practicing stunts while Clark precariously dangled
over the edge compounded the job's inherent and
obvious perils.[120]

After the armistice in 1918, Clark was among the
first soldiers allowed to return home. He did not
express in speech or through his paintings the
horrors he had witnessed in Europe. However, his
military service left one clear consequence: he
was completely deaf in one ear. A specialist deemed
the deafness temporary and recommended treat-
ments but also urged Clark to live in a warm climate
where the condition would not be aggravated.
Medora recalled their quandary: "We knew nothing
of warmer American country. Neither California
nor Florida appealed to Alson, but California had
one lure—mountains," despite Medora's observation
that they were "unconsciously prejudiced against it
[California] through its promotional literature."[121]

Much of the promotional literature on Southern
California in the late nineteenth and early twentieth
centuries was financed by the railroads and the
tourist industry. Descriptions of California's virtues
reached rather epic proportions. For example, a
writer in the journal *Western Art* waxed passionate
over California's charms:

Many there are who have journied [sic] to the
confines of our terrestrial world in search of
an ideal land . . . and they have found such a
land—as near as may be—in the Southland of
California. And they have called it the "Land
of Heart's Desire."[122]

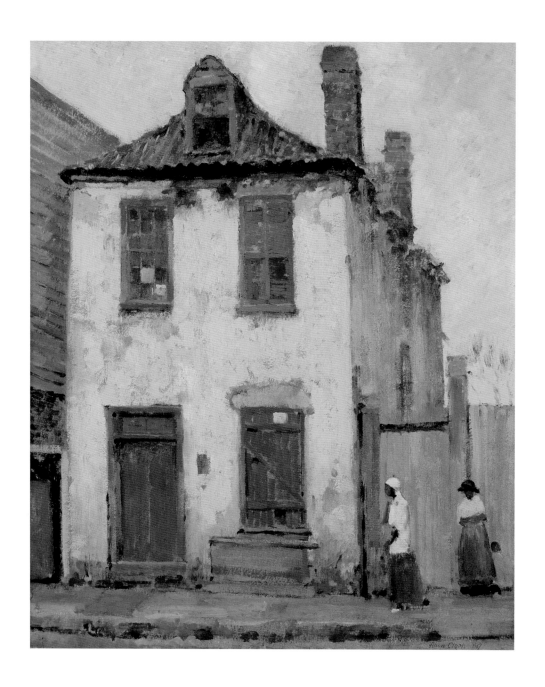

PLATE 44

Catfish Row, South Carolina, c. 1917

Oil on board, 18×15 inches
Collection of Paul and Kathleen Bagley

PLATE 46

Charleston Houses (also known as *St. Michael's Alley*), c. 1917

Oil on canvas, 32×26 inches
Private Collection

Although the Clarks were unconvinced that Southern California was Camelot, it had the required climate. Rather reluctantly, they boarded a train for Los Angeles and arrived in February 1919. On the trip, Clark announced to Medora that "painting was a thing completely of the past, and that he never cared to paint again. . . ."[123]

Although Clark's diaries do not refer to this rather radical pronouncement, fresh from the horrors of war, he may have viewed his painting career as insipid. Readjusting to civilian life entailed more than resuming daily routines; it also required looking ahead to the rest of one's life without the burden of the recent past.

The Clarks' arrival in Los Angeles marked a significant line of demarcation in their lives; Southern California would become their home. Clark's desire to paint returned. His spirits were buoyed, and he slowly regained his artistic and emotional footing. Relocating to California signaled a new start for his career, forcing the artist to confront life's challenges without the safety net of established friends and colleagues.

Medora Clark arriving in
Los Angeles, February 1919
Collection Jean Stern,
The Estate of Alson Clark

PLATE 47

Medora, c. 1917

Oil on canvas, 26×21 inches

Collection of Mr. and Mrs. M. James Murphy

PLATE 48

Miss Matthew's Kitchen, c. 1917

Oil on canvas, 28 × 38½ inches
Collection of Dr. and Mrs. Michael Dosik

California

Clark's ear treatments began when they reached Los Angeles. After a few weeks, when he was allowed to take short, local trips, the couple ventured to San Gabriel, home of one of the California missions. Although Clark previously had expressed reservations about resuming painting, the allure of the mission prompted him to go immediately to an art supply store for materials.

Clark's fascination with mission ruins was further piqued when the couple visited Mission San Juan Capistrano in the beginning of March. They were "unprepared for the beauty of the mission; we stopped at the gate to absorb it."[124] Quickly realizing that a prolonged stay in Capistrano was inevitable, Medora arranged for the couple to rent a room and a studio at a local boardinghouse. They returned to Los Angeles, gathered some belongings, and returned to Capistrano in mid-March.

The Spanish colonization of California was facilitated through a chain of twenty-one missions constructed beginning in 1769. Their history is inextricably linked to the state's identity. However, that history was written and rewritten several times during the nineteenth and twentieth centuries. Artists gravitated to the missions, generating ubiquitous images.[125]

Father Junípero Serra founded Mission San Juan Capistrano on November 1, 1776—ironically at nearly the same historical moment as the American Colonies' declaration of independence from England. One of the most ambitious and significant accomplishments at this mission was the construction of a great cathedral (built 1797–1806). Although a formidable structure with several domes and a bell tower, it could not withstand the powerful earthquake that shook Southern California on

December 8, 1812. Only rubble and the remnants of walls mark its once majestic presence.

Although it is now generally accepted that the mission system devastated the indigenous population, some of the literature circulated in California during the late nineteenth and early twentieth centuries transformed the real hardships imposed upon the Indians into accounts of benevolent missionaries who, in the best interests of their charges, turned aboriginal, uncivilized individuals into God-fearing Christians.[126]

> Italy has its ruins, its Coliseum, and its Forum; Germany its castles . . . and Spain its slumbering Alhambra. . . . With equal pride California points to its ruins. True, they cannot boast of great antiquity, neither do they tell of nations who fought and conquered; their tale is of the heroic deeds of noble men, who yielded fame and fortune for the glorification of God in the then heathen California.[127]

Given the state's scant political and social history, the missions established a historical continuity and were positioned by a clever spin. The Southland had neither a Mayflower Society nor a local chapter of the Daughters of the American Revolution. The European conception of civilization—in the form of art, architecture, and a literary culture—was still in its relative infancy. Therefore, despite the dubious circumstances, the decaying mission buildings represented tangible historic traditions.

Clark painted the crumbling, mellow walls of the buildings, the courtyards, fountains, and flora. Notebooks document a significant number of mission paintings from spring 1919 well into the 1920s. The courtyard at San Juan Capistrano, surrounded by an arcade, was a favorite spot, and he painted

several iterations of a particular view. In one varia-
tion, *Mission San Juan Capistrano* (plate 61), the
observer is placed outside the arcade amid a bounty
of overflowing vegetation. The ruins of the great
stone church, with its arbitrary forms and crenel-
lated brickwork—particularly the decaying exterior
surfaces—were inspirational. *Ruins of San Juan
Capistrano* (plate 51), compositionally cropped and
intensely focused, underscores the dignity of this
structure, even in its ruined state. Clark's unusual
blue highlights proved to be a successful tactic.
Exposed layers of brick vary from shades of burnt
sienna to ocher, and the keen tactility of the surfaces
is achieved through *bravura* brushstrokes and layering
of paint. Clark also did several paintings of the mis-
sion at night, seen here in *Moonlight in the Mission*
(plate 50). Even at this date, the influence of
Whistler's nocturnes still informs Clark's work.

Mission San Juan Capistrano lured Impressionist
painters (including Colin Campbell Cooper, Arthur
Rider, Donna Schuster, Gardner George Symons,
and William Wendt) well into the twentieth century.
Clark's ongoing fascination with the subject also
suggests his interest in historical California. One
could argue that historical subjects always intrigued
Clark—whether European or East Coast architec-
ture or the history-in-the-making in Panama. By
the mid-1920s, Clark's understanding of California
history would culminate in large, didactic murals,
a decision undoubtedly fueled by his exposure
to the missions.

By mid-May 1919, Clark declared his ear "cured."[128]
The couple returned to Los Angeles and left
California, after purchasing a small plot of land with
a shack on the Arroyo Seco in Pasadena to serve as a
"temporary home until France is back to normal."[129]
They summered at Comfort Island and by Novem-

ber were in Old Lyme, Connecticut, visiting close
friends Harry Hoffman and Lawton Parker. Old
Lyme was a long-established Impressionist art
colony that, in many respects, still revolved around
the Florence Griswold House.[130] Hoffman and
Clark painted together at the old brick mill in Old
Lyme. In Clark's autumnal scene *Mill, Old Lyme*
(plate 49), remnants of colored leaves cling to a
large, arching branch while denuded trees cast their
shadows across the building.

The Clarks spent Christmas in Chicago and
returned to California (with their long-time house-
keeper, Lena) on January 1, 1920, to inspect their
Pasadena "shack." Clark noted: "This morning had
hard time trying to get to Pasadena Flower carni-
val."[131] The flower carnival was the Tournament of
Roses Parade, a well-established Pasadena tradition
by that date. (The first Rose Parade was held in
1889.) Arriving at their new digs, 1149 Wotkyns
Drive, Medora recalled her initial reaction:

> There were four rooms, one with a crudely
> built-in buffet; and as a sort of afterthought a
> lean-to kitchen with a sink… but there was, to
> our joy, a single bulb to a room with electricity,
> a luxury we had never before possessed. "It's a
> castle," I felt compelled to announce. . . . [132]

Major construction—including moving the struc-
ture to another location on the property and build-
ing a studio—was their first priority. Nonetheless,
Clark left for Chicago in February to see a group
of his California paintings exhibited at Henry
Reinhardt and Sons. The show was a critical and
financial success, with one reviewer declaring:
"Mr. Clark gives the impression that he enjoyed the
sunshine and the spell of the surroundings as he
painted and certainly never has he sent canvases

PLATE 49

Mill, Old Lyme, c. 1919

Oil on canvas, 30 × 36 inches

Collection of Roger C. Hamilton, Atlanta

of more impelling charm and a somewhat exotic beauty."[133] With the war now over, the critics and public were once again eager to turn their attention to art, especially work such as Clark's, which struck a familiar chord.

With the studio completed that spring, Clark spent a good deal of time traveling locally; he also renewed contact with colleagues from France, Arthur Burdett Frost and his son John, who were now living in Southern California. By August, Clark wrote: "Have made more progress this month in my work than ever before. Awfully interested and keen on it and delighted to think I can have an uninterrupted summer of work, for I haven't had the opportunity for years."[134]

The desert was easily accessible, and during the 1920s Clark often traveled to Palm Springs—sometimes accompanied by John Frost—eventually constructing a small studio there in 1924. Works such as *Desert Verbena, Palm Springs* (plate 68), in which the muted palette reflects the soft, modulating desert light and the composition is peppered with colorful vegetation, show Clark at his best. The artist maintained his devotion to Impressionist practices—painting quickly *en plein air*—but the divided brushwork and flickering, fragmented light seen in earlier paintings from Giverny, the Thousand Islands, and Panama, are absent in many desert scenes. Instead, larger areas of unmixed colors, with an almost scratchy surface texture, dominate the canvases. The area in and around Pasadena provided continual inspiration. He could paint the Arroyo Seco or the San Gabriel Mountains literally from his backyard, as in *After the Storm, Altadena* or *The Promoter*

(cat. nos. 55 and 57). His home, featured in *The Artist's Cottage* (plate 62), proved an accessible and desirable subject.

Clark entered a new phase of his career in 1921 when he accepted an offer from his friend Guy Rose, Director of the Stickney School of Fine Arts in Pasadena, to join the faculty. Rose had returned to California in 1914, became an instructor at the school, and was chosen as its director in 1918.[135] At first, Clark taught evening classes. When Rose suffered a debilitating stroke, Clark became director—a role he fulfilled devotedly for many years.[136]

Another milestone that year was Clark's first solo exhibition in Southern California. Earl Stendahl, the most powerful dealer in Los Angeles during the 1920s, hosted the exhibition, which included both East and West Coast scenes. Concurrently, Clark's works were on exhibition at the Corcoran Gallery in Washington, D.C., and The Art Institute of Chicago.

But, by far, the most salient event of 1921 was the birth of the Clarks' son, Alson Jr., on July 12. In February Medora discovered that she was pregnant; Alson wrote in his diary that it was "the most wonderful month of my life."[137] The euphoria of having a child was tempered by the rigors of caring for a newborn. Accustomed to freedom and quiet, Clark bemoaned in August, "my painting days are over, I fear."[138] That prediction was unfounded, for, in reality, he spent a good part of the late summer and early fall traveling and painting locally with Orrin White and John Frost; his notebooks document trips to Banning, Hemet, the High Sierra, and Palm Springs.

PLATE 50

Moonlight in the Mission, c. 1919

Oil on canvas, 26×32 inches
Private Collection, Courtesy of The Irvine Museum

PLATE 51

Ruins of San Juan Capistrano, c. 1919

Oil on board, 31×25 inches
Private Collection, Courtesy of The Irvine Museum

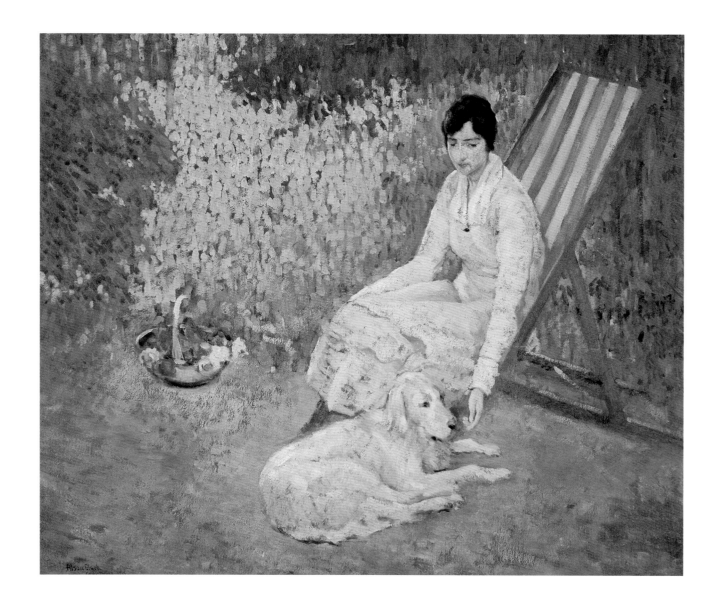

PLATE 52

Viola and Major, c. 1919

Oil on board, 25½ × 32½ inches

Private Collection

While Clark spent his early years in California exploring the state, he took his first of several trips to Mexico in spring 1922, accompanied by his friend Garret Van Pelt. The trip was fairly brief, but Clark filled sketchbooks and took hundreds of photographs.[139]

Fall 1922 marked another defining moment. Although they never imagined that Alson would "abandon Paris," it was financially untenable to retain both residences and the Clarks made Pasadena their permanent home. When their belongings arrived in California, Medora combed through the contents of her prior, much more formal existence, which required white gloves, veils, and "all the frills of Parisian life." Clark welcomed the "French easels . . . the wonderful rolls of French canvas . . . the sketchbooks, and even the tubes of slightly hardened paint."[140]

Clark's oeuvre was shaped by his European experiences and he arrived in California as a fully mature artist. It could be argued that his relocation precipitated the best of all possible worlds: his established interest in landscape and historic architecture was transferred to the state's distinctive characteristics. He acquired a home and started a family, while managing to keep his art in the national spotlight. However, beginning in the early 1920s, certain critics in California began to suffer art-historical amnesia in respect to his life and work prior to arriving in the Southland. Clark's predicament was similar to the experience of many cosmopolitan artists who migrated to California, ultimately finding that their work was primarily associated with the state and not viewed in a larger, national context.

An Artist Sensitive to Beauty

After many years of spontaneous travel and a laissez-faire attitude toward home ownership, the Clarks, following the birth of their son, decided to seek more structure and stability in their lives. Alson still wanted to travel, but now to destinations closer to home. Entranced by Mexico during his first trip in 1922, he quickly organized another trip in 1923 with the painter Orrin White.

In March 1923, the *Los Angeles Times* noted: "The lure of Mexico is strong on Alson Clark. . . . He will go as far as Manzanillo by boat, and then, by slow stages he will pass inland to Mexico City and down to Cuernavaca. After that he will hunt up a mule and ride to a town called Tasco [sic] where there is an eighteenth-century palace in a pleasant state of decrepitude—just Alson's sort of subject."[141] In fact, images of decaying buildings were now long associated with Clark's oeuvre, and he fully realized their commercial appeal. *Laguna Life* observed: "Alson Clark and Orrin White have gone in . . . search of new themes for the brush. Old Mexico is their El Dorado, and Mr. Clark, who is one of those fortunate individuals who never loses their early enthusiasms, hopes to find a natural continuance for the work begun in Spain."[142]

Considering the interval between trips, it may be an overstatement to suggest this was a "natural continuance." However, his Spanish paintings had been well received and Clark anticipated that the Mexican subjects (with clear Spanish influence) would be equally successful. Clark had proved willing to exhibit subjects that were unusual—tempered by his need (and desire) to have some commercial success. However, this is not to suggest that he developed an overall strategy for Mexico based on commercial considerations. Mexico's history, culture, and architecture were the artist's primary concern. That the fruits of these trips might yield financial rewards only added to the overwhelming appeal.

Despite his maturity as an artist, Clark still grappled with insecurities. Writing to Medora from Cuernavaca, he was circumspect: "I am anxious to have you see the pictures for you know I think more of your judgment than anyone else's." He also missed his family. "I have a great slogan now, and that is I keep saying to myself when I am painting, 'Remember you are painting for your wife and baby,' and I just do my very best."[143]

Judging from the number of entries in notebooks, Clark worked very successfully on this trip. He hired a boy to carry his paint box and easel—and also light cigarettes, purchase food, and rent a burro if necessary.[144] Cuernavaca offered sustained inspiration. *Sol y Sombra* (plate 59) underscores Clark's interest in architectural devices, such as arches within arches that establish spatial recession and draw the viewer into the painting. Richly textured brick and walls, achieved through the sketchy application of paint, are covered in lavender shadows. The sombrero and traditional costumes bespeak the Spanish heritage.

Cuernavaca's streets, arcades, alleyways, churches, and the fabric of life all resonate in his many representations. In *Road to Cortes, Cuernavaca* (plate 58), the viewer's vantage point is looking down a brick road into the town. Colorful red-tiled roofs and pink-hued walls are nestled between the lush green vegetation. Mountains in the background are suggested by sketchy brushstrokes. And, typical for Clark, lavender shadows are cast throughout.

Some of Clark's most successful efforts were painted from rooftops, offering a bird's-eye view of the city with its architectural landmarks. The panoramic

After the Shower, Cuernavaca (plate 54) includes two main architectural structures, the cathedral and the Guadeloupe parish.[145] Clark's rich and colorful palette is deftly integrated—repeating the lavender, for example, in puffy white clouds and the antediluvian buildings. The work underscores the beauty of this charming and important town that was once home to the Spanish conqueror of Mexico, Hernando Cortés, and a vacation destination for Emperor Maximilian. This large and impressive canvas was awarded first prize in the Southwest Annual Competition of 1923.

Painted in a section of Mexico City, *Carmen Gate, San Angel No. 2* (plate 56), with its sinuous walls and impressive portico, highlights the two domed towers of the Convento de Carmen. The background is achieved through large brushstrokes and a soothing contrast of colors.

Despite his progress, the many months in Mexico left Clark emotionally exhausted. "It's dreadfully hard to stay away," he wrote to Medora. "You don't know what courage it takes. . . . I imagine the precious baby is talking more all the time and doing new things. I am just crazy to see him."[146] Nonetheless, he returned from Mexico with enough paintings to organize an exhibition in San Diego in August at the San Diego Museum of Art—his first solo show there. The reaction was overwhelmingly positive:

> Mr. Clark . . . the internationally known painter, has recently returned from Mexico City and the surrounding country, and to the discriminating art collector and art lover who has followed the work of Clark, especially in the paintings of old walls and buildings in France, this opportunity

to see the marvelously colored buildings of Old Mexico is a rare one. . . . [147]

From San Diego the exhibition traveled to O'Brien Art Galleries in Chicago. Medora recalled: "Mexico was new to Chicago, too, and it welcomed Alson's treatment of a new country with delight and shared his enthusiasm in presenting it. To his surprise, it surpassed all his other shows in interest and sales; and he was bewildered but pleased with the results."[148] The critics once again applauded Clark's originality:

> The hasty traveler, in a conducted party, goes the way of the tourist, seeing Mexico City much like any other city in the world, especially those of the European continent. But the painter, knowing the peculiarities of strange cities as does Mr. Clark, leaves the beaten highway to meet Mexico herself as barbaric and alluring as a gypsy walking along the byways.[149]

With the tremendous success of Chicago, many of the paintings went on to New York for an exhibition at Grand Central Art Galleries, with which he now established a long-term relationship.

Clark's willingness to immerse himself in different cultures, proven in France, Spain, Dalmatia, Panama, and now Mexico, was a consistent element throughout the patchwork of his career. With this understanding, his emerging characterization as a "California artist," starting in the mid-1920s, seems incongruous. While Clark spent the latter portion of his career in California, over half of his life was spent elsewhere. One observer believed that "California can justly claim Alson Skinner Clark as her own. Although born in Chicago, and spending most of his time in foreign lands, it is here that he always returns with his canvases."[150] Although

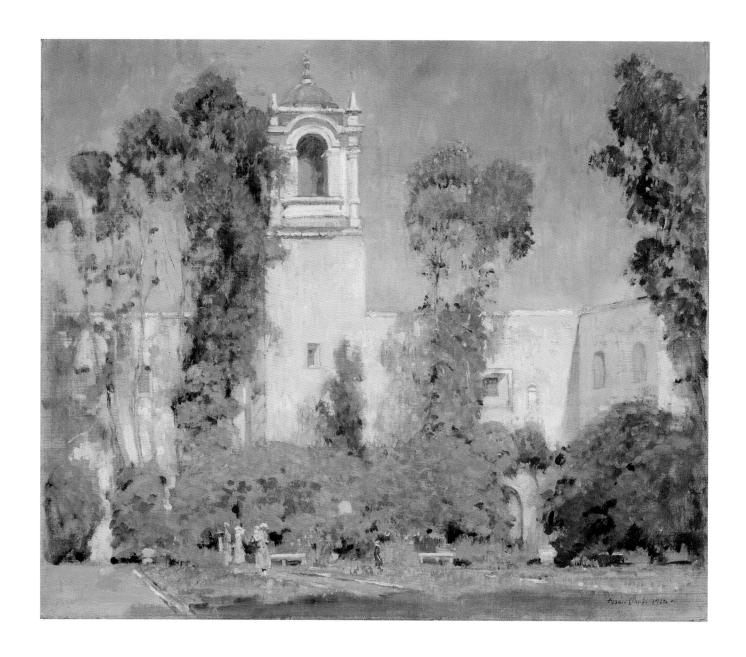

PLATE 53

Montezuma's Garden, 1922

Oil on canvas, 18¾ × 22 inches
Collection of Earlene and Herb Seymour

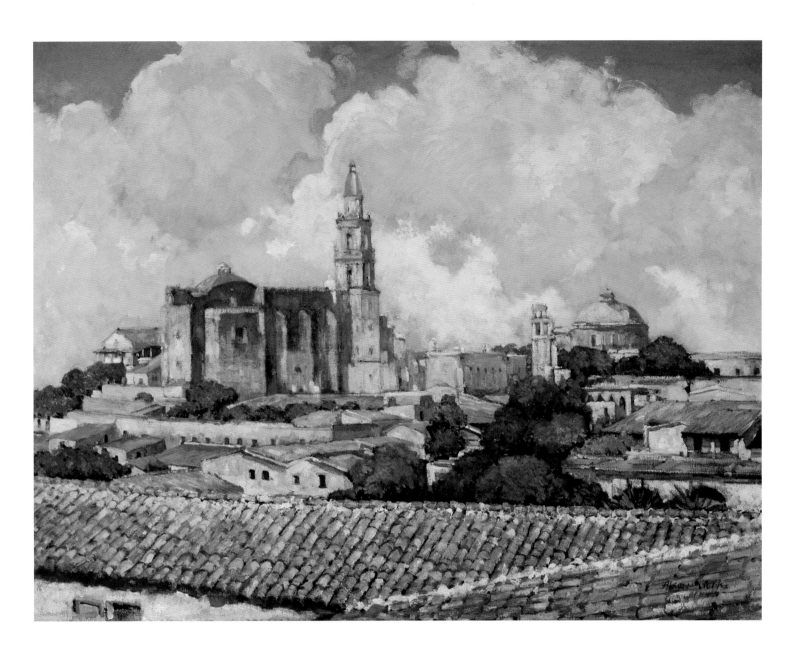

PLATE 54

After the Shower, Cuernavaca, 1923

Oil on canvas, 36×40 inches

Collection of Gardena High School/Los Angeles Unified School District

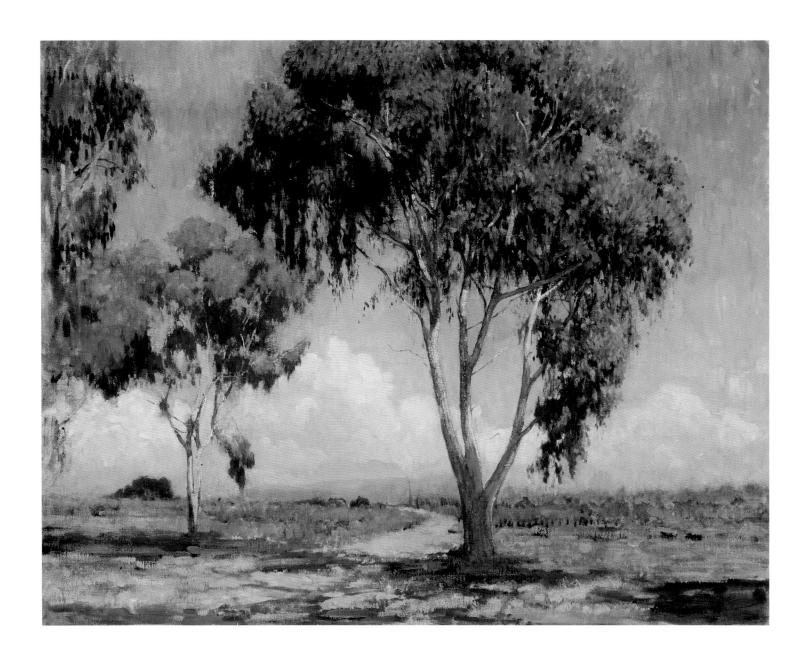

PLATE 55

After the Storm, Altadena, 1923

Oil on canvas, 30×38 inches

Collection of Bette and Stewart Schuster

PLATE 56

Carmen Gate, San Angel No. 2, 1923

Oil on canvas board, 18×22 inches

The Buck Collection, Laguna Hills, California

PLATE 57

The Promoter, 1923

Oil on canvas, 26×30 inches

Collection of Mr. and Mrs. Thomas B. Stiles II

PLATE 58

Road to Cortes, Cuernavaca, 1923

Oil on canvas, 26×32 inches

Collection of Ranney and Priscilla Draper

acknowledging that Clark spent a significant portion of his career elsewhere, the reviewer's intention was to help California "claim" Clark. The critic Sonia Wolfson, clearly ignoring the artist's prior interest in Chicago, Charleston, and Watertown, concluded that Clark "used to deplore the scarcity of paintable habitations in America, but in California has found ample scope for his fondness for architectural subjects."[151] Antony Anderson, critic for the *Los Angeles Times* until 1926, was a great advocate for Impressionism and things Californian. Beginning in 1923, he began to shape Clark's transformation:

> All globe-trotting artists land at some time in Southern California, and not a few of them unfurl their tents and decide to remain here forever and a day. It seems to be actually true—therefore—what we have seen and heard so often stated in print and out—that Southern California is the Mecca of painters. For many years Alson Clark has been a pilgrim and a wayfarer. . . . But he hadn't found Mecca. Four years ago he came to Southern California and remained.[152]

Clark's connection to California is irrefutable. However, Clark, along with many other artists who relocated to the state, found himself in a dilemma not of his own making. Although established, successful, and well-heeled, Clark and others found their reputations became tied to the rampant boosterism of the period, their lives prior to California dismissed or, worse, ignored.

Southern Californians possessed a strong regional pride, identified by one Chicagoan who visited the Southland in 1894: "It is a strange characteristic of those people there, an interesting but harmless hallucination that each one believes he possesses from his own veranda the finest view in Southern California. . . . It is a queer country, but, after all, it is gratifying to find that there is some corner of the world where everyone seems to feel a contentment with his lot that arises almost to the dignity of a passion."[153]

Bolstered by the unrelenting power of real estate interests, the Chamber of Commerce, and even the Automobile Club of Southern California, the Arcadian characterization of the Southland reached a fever pitch in the teens. Such sentiments were easily grafted onto the parlance of art critics. California was hailed as a crucible for artists, and its artists given the cognomen "artistic pioneers."

> The Art of the West, full of vigor and the promise of youth, reveals the same dauntless qualities of fearlessness and strength that stirred in the pioneers of early days, prompting them to leave the conventions, customs, and ease of the east and willingly brave the hardship of a new land in order that they might more freely shape their own lives in their own way. The artists, imbued with the same pioneer spirit, have boldly shaken off every influence superimposed upon them from the outside and are doggedly blazing their own trail to success or failure. . . . With but few exceptions, the Western artists have had practically no training, following the guidance of their own genius. . . . [154]

This missive is both powerful and moving; unfortunately, it is also inaccurate. Most artists working in California were hardly "artistic" pioneers. Trained in the major art centers of the United States and Europe, many, like Clark, arrived in California with a mature aesthetic. They were well-to-do, educated, and cosmopolitan.

PLATE 59

Sol y Sombra, 1923

Oil on canvas, 25×30 inches

The Buck Collection, Laguna Hills, California

PLATE 60

La Jolla, 1924

Oil on canvas, 18½ × 22 inches
Private Collection, Washington, D.C.

Yet, California's isolation from the mainstream was constantly voiced in the early twentieth century and still holds currency today. Raising the specter of isolationism achieved several things. Arguably, it insulated artists in California from the more discerning and harsh Eastern critics: How could secluded Western artists possibly be expected to keep up with the most avant-garde trends?

In fact, although Impressionism arrived and remained in California long after the style lost its preeminence in the East, Southern California was not just a bastion for Impressionism and Post-Impressionism. By 1919, Stanton Macdonald-Wright, founder of Synchromism, had moved to Los Angeles. Modernist art was actively promoted through his teaching and proselytizing; he also led the progressive Los Angeles organization The Modern Art Workers.[155] Supporters of "traditional" art were dealt a serious blow when Arthur Millier replaced Antony Anderson as critic for the *Los Angeles Times*. At times, Millier could be an especially vitriolic detractor of Impressionist painting.

While it is true that Los Angeles lacked the cosmopolitanism of Paris or London, painters in Southern California could reasonably expect modern conveniences that were lacking in Europe. Although the Clarks were no strangers to rudimentary living, as they approached middle age the need for certain basic amenities was a bit more pressing. Medora discussed the distinctions between California and Europe.

> Background has an enormous influence on the painter. . . . Briefly, he must get a punch from what's about without sensing the punch. That's why Europe has fed the painter. Spain is rampant with such spots, so is France; but

both countries are barren of Mazda bulbs, jiffy heaters, open plumbing, sewers, floorplugs, and gas at 22½. The painter is human; he doesn't in the least object to having the rough spots smoothed for him, and thrown in with a landscape that stirs.[156]

In fact, Los Angeles was transformed into a modern city during the 1920s. The population exploded, the price of real estate skyrocketed, and the economic growth, tied into the burgeoning Hollywood film industry, was on an upward trajectory. The infrastructure that nurtured the arts, including schools, patrons, museums, and exhibiting organizations, began to flourish.

Perhaps one of the most compelling arguments for Clark to be understood in a national context during his years in California was his enduring relationship with collectors throughout the country, especially the Midwest and East Coast.[157] One of his most prestigious collectors and friends—even after he relocated to California—was Edward B. Butler, one of the founding members of Butler Brothers, a large Chicago-based mail-order firm.[158] A philanthropist, art patron, and himself a painter, by the late 1880s Butler was a leading figure in the Chicago art community. Among other distinctions, he was chairman of the finance committee for the World's Columbian Exposition (the 1893 Chicago World's Fair) and a trustee of The Art Institute of Chicago.[159] Perhaps Butler's most enduring gift to the art community was a donation in 1911 to the Art Institute of eighteen George Inness paintings.[160]

It is likely that Clark and Butler met in Chicago. According to extant records, Butler began to collect Clark's work in 1912 (for example, *The Blue Wagon, Spalato*, 1912, unlocated) and continued to purchase

PLATE 61

Mission San Juan Capistrano, 1924

Oil on canvas, 26×31 inches

Edwin H. Clark Estate

PLATE 62

The Artist's Cottage, c. 1925

Oil on canvas, 36×46 inches
Collection of Gregory A. Young

PLATE 63

Floral Still Life, c. 1925

Oil on canvas, 36 × 32 inches
Rowe Family Trust

PLATE 64

Mount Baxter, Owens Valley, c. 1925

Oil on canvas, 26×32 inches
DeRu's Fine Arts, Laguna Beach, California

PLATE 65

San Diego Bay, c. 1925

Oil on canvas, 26×32 inches
Collection of Dr. and Mrs. Edward Boseker

through the 1920s (*Montezuma's Garden,* plate 53; *Cathedral Corridor,* 1923, unlocated). Butler was also a painter (he began to exhibit at The Art Institute of Chicago in 1911 under an assumed name) and, according to Medora, he "came to Paris each spring for a period of painting with Alson and to scout for Inness canvases which he had begun collecting."[161] Beginning in the mid-teens, Butler began to spend winters in Pasadena. Clark purchased his lot in Pasadena from Butler—a part of a larger parcel owned by the collector. The connection between Clark and Butler cannot be underestimated. Until his death in 1928, Butler was a prominent member of the art communities in Southern California and Chicago. Clark's inclusion in Butler's collection (with the likes of Inness) is certainly a testament to his skills. And, interestingly enough, when Butler wanted to study painting, he turned to Clark as a mentor and teacher.

Once Clark settled in Pasadena, he strongly identified with the growing local art community. He accepted a project in 1925 that became an important landmark in his adopted city. That year, The Pasadena Playhouse began construction on a new theater building. When the architect suddenly resigned, Clark was asked to assume responsibility for completing the project. Although at first blush he seemed an unlikely candidate, a major focus of the project was the interior decoration and the design of a decorative curtain; perfectly equipped to do both, Clark also engaged the the local architect Dwight Gibbs.[162]

Because the theater design was influenced by Spanish/Mexican style, Clark returned to Mexico for fresh ideas and inspiration in addition to gathering new material for future exhibitions. For the curtain, Clark settled on a Spanish galleon under full sail, a theme he had explored earlier in his notebooks. To complete this massive curtain (approximately twenty-by-thirty-two feet), Clark enlisted the assistance of his students from the Stickney School.[163] The theater and the curtain opened to rave reviews. "An artist, a singer or an actor is familiar with applause," stated Medora. "But when the Galleon curtain was revealed there was a thundering burst of admiration from the entire house with the cries of not 'author,' but 'artist.'"[164]

Following this unusual undertaking, Clark took on an even greater challenge when he accepted a major commission to produce murals chronicling the history of California for a Los Angeles theater, financed by J. Harvey McCarthy, a native Californian and wealthy entrepreneur. In classic American Renaissance fashion, McCarthy asked a number of artists to collaborate. Dwight Gibbs, Clark's associate from the playhouse, agreed to design the interior. The well-known Frank Tenney Johnson agreed to paint the drop curtain and its flanking murals.[165]

Although Clark had just completed the curtain for The Pasadena Playhouse, his experience as a muralist was limited to the Mancel Talcott School Mural in 1902. However, as a student he painted murals in his home on Comfort Island that are unknown to the public. Beginning in the early 1890s, Clark used the walls of the downstairs rooms and main stairwell of his family's home as a huge canvas, decorating them with Japanese-style motifs and scenes. Clark's interest in *Japonisme* was fostered by Chase and later by Whistler, both of whose use of Japanese motifs is well known and documented. Clark's intricately costumed figures are highly accomplished.[166]

PLATE 66

The Arrival of the Oregon at San Francisco, c. 1925–26

Oil on canvas, 87×103 inches
Edenhurst Gallery, Los Angeles

PLATE 67

Monterey Park, c. 1925–28

Oil on board, 20×24 inches
Collection of Gregory A. Pieschala and Dorothy L. Shubin

Left, Comfort Island living room, 1973
Photograph by Alce Ann Clark Cole, courtesy of Edwin H. Clark II

Right, Comfort Island staircase landing showing Clark's Japanese figure decorations, c. 1972–73
Photograph by Alce Ann Clark Cole, courtesy of Edwin H. Clark II

This early attraction to mural painting seems to have gone untapped for many years. One can easily speculate on various reasons. Large mural projects require a significant dedication of time. Clark's travel schedule may have left him unwilling to commit to a long-term enterprise. He also did not teach until mid-career, leaving him without the help of students who often worked with teachers on major projects. And finally, until J. Harvey McCarthy, perhaps no one asked. However, now a leading figure in Pasadena, Clark had proven he could work on a large scale and, as always, he was enticed by the challenge.

McCarthy did not dictate the subjects but mandated that they represent the history of California; he intended the murals to be didactic tableaus. In fact, a Historical Committee was established to solicit individuals to either loan or donate items to a "museum" of sorts, promising that the items would be properly exhibited at the theater.[167] McCarthy's concept was infused with a large dose of cultural nativism, an attempt to underscore the historical traditions of the state. To ensure Clark's accurate interpretation of details, McCarthy financed a research trip to San Francisco, to Monterey, and finally to Sacramento, where the artist spent a week examining documents at the State Library.[168]

Clark settled on seven subjects: *The Founding of Los Angeles; Jedediah Smith at San Gabriel; End of a Long Day; The Arrival of the Oregon at San Francisco; Commodore Sloat Taking Monterey; Governor Burnett Leaving for San Jose;* and *The Passing of the Pony Express.* He worked up large-scale preliminary sketches and, with a set of weights and pulleys especially designed for his studio, painted the murals. Each subject was carefully considered:

they were not only large but complicated, many integrating figures, buildings, and ships.

When the theater was destroyed in 1969, the murals were removed and sold, but one extant work is *The Arrival of the Oregon at San Francisco.* Although California was accepted as a state on August 13, 1850, it was not until October 13, 1850, that the news actually reached San Francisco. The telegraph was still in its infancy, so important communications were often delivered by ship. This approximately eight-by-nine-foot scene depicts the arrival of the vessel that carried the news. Clark has beautifully rendered the scale while incorporating a duality of styles: more defined drawing punctuated with freely rendered passages. People mill about—some in Calistoga wagons, some on foot, and others on horseback. We feel transported back to that critical moment in California's history, yet on the other hand, the new state's citizens go about their business, unaware of the drama unfolding before them.

The opening of the theater in May 1926 was highly anticipated and met with encomiums. One critic observed that Clark's paintings were "all together a splendid gallery of historic Californiana."[169] Alma May Cook was even more complimentary:

> Nothing theatrical, these paintings are colorful but not bizarre, brilliant but not flamboyant, striking but not catchy—they are a gift of art to history in dramatizing and visualizing that which we too often forget in our everyday affairs.[170]

They received national attention in January 1927, when the *American Magazine of Art* reproduced the entire series.

California did not boast a surfeit of murals or mural painters prior to the 1930s and the advent of the Works Progress Administration. On a most basic level, mural painting is generally associated with significant public buildings or private homes of wealthy patrons: Southern California had few of either pre-1900. The most significant mural project during the 1920s was the decoration of the Los Angeles Public Library, c. 1927–32 by artists such as Albert Herter and Dean Cornwell. Herter's eight historical murals were ambitious. But even more grand was Cornwell's series whose complicated program included some three hundred figures, covers nearly nine thousand square feet, and depicts the history of California in twelve scenes.[171] It is certainly probable that either Herter or Cornwell saw the Carthay Theatre murals. Clark paved the way, and other artists soon followed in his footsteps.

Although Clark was preoccupied during 1925 and 1926, he managed to mount two exhibitions: one at Grand Central Art Galleries (October 1925), the other at O'Brien Art Galleries (March 1926). Once again, the Mexican scenes were highly appreciated. "Alson Clark is showing recent paintings of Mexico at the House of O'Brien. His is the vision that sees the unusual in the tropical world. An old story, fresh zest. . . . Mr. Clark paints better than ever."[172]

The Clarks spent June through October 1926 at the Comfort Island home. Although Medora wondered if the Eastern foliage would entice him to remain, Clark had other plans. The dimensions of the Carthay Circle Theatre murals proved his studio inadequate: large commissions required more space. When they returned to Pasadena, he purchased a site on Pasadena Avenue and, with the help of his friend Reginald Johnson, built an enviable studio. He taught classes in the studio but still found the

time to travel, paint, and keep up correspondences with old friends.

By 1927, the American economy was in flux. Clark's income was supplemented through his interest in the family paint company but business was decreasing.[173] In April, the vice-president of the company announced the downturn: "Business is not what it has been in years gone by. . . . " The situation became increasingly dire by August: "Business has not been very good. . . . When you get to where you need more [money], we can, of course, take care of you. If necessary we can apply it on the note we owe you. In fact, under the circumstances you probably will be getting greater returns from the work you will be able to turn out in your new studio than the company is paying you in interest, however, we will meet your views whatever they are."[174]

Neither Clark nor Medora expressed concern over financial matters, but he continued to exhibit and to seek shows in New York and Chicago. Considering the indecisive economic climate, Clark maintained a strong client base. When, in 1928, the Pasadena First Trust and Savings Bank (now Bank of the West) decided to commission four large murals (each ten-by-sixteen feet), they contacted Clark. The artist eagerly agreed, his new studio easily accommodating large-scale works. The subjects were to be the four major California industries: oil, shipping, motion pictures, and agriculture.[175] The paintings remain in situ. The works exhibit the dual techniques now typical of his mural paintings: a blend of carefully articulated drawing punctuated by Impressionist passages.

The murals received an overwhelmingly positive reception. Clark was praised for "making a real contribution to the growing use of mural painting in

PLATE 68

Desert Verbena, Palm Springs, 1926

Oil on canvas, 26×32 inches

Collection of Paul and Kathleen Bagley

PLATE 69

La Jolla Cave, 1928

Oil on canvas, 33×38 inches
Collection of the Automobile Club of Southern California, Los Angeles

the adornment of business and public buildings."[176] This observation is particularly significant in respect to the growing importance of murals through the Works' Progress Administration. Without abandoning his Impressionist easel pictures, Clark understood the potential power of art in public spaces, and he was willing to test the boundaries of his capabilities. He never abandoned Impressionism, even if major commissions dictated other strategies.

By 1929, the effects of the stock market crash had devastated the art market. Lacking buyers and patrons, artists bartered their work for goods, groceries, or essential services, such as a visit to a doctor or dentist.[177] Given the economic climate, Clark was fortunate to receive a major commission that year from The California Club, a private men's organization. A new facility on Flower Street in Los Angeles was under construction (the club and building remain today). The architect, Robert Farquhar, required murals for the Ladies' Reception Area, now called the Gold Room. Medora recalled that this commission was "without restrictions" and that Clark believed the decorations "should not be frivolous, but should be feminine and light."[178]

He created eight large oval portraits of women, each clothed in a different, colorful costume and placed against an unadorned background (see plate 71). The costumes range from traditional Spanish and Mexican to early twentieth-century fashions. Medora recalled that he chose the costumes "not as period pieces, but something epochless of pleasing color and design."[179] When the club opened in August 1930, the murals were singled out for praise.[180]

While painting the murals, Clark managed, in 1930, after a hiatus of three years, to organize a major exhibition of easel paintings at Stendahl Galleries.

Many of the paintings, scenes of La Jolla, Palm Springs, and San Diego, were painted the previous year; others included Mexican paintings from his earlier trips. The critical reaction was enthusiastic. Even Merle Armitage, who could be exceedingly acerbic, praised Clark's efforts (albeit in a measured way). "I have always thought of Alson Clark as a very fine decorator, for he has a splendid sense of pattern and conventionalized form. . . . His work always charms and delights, and even though he is not profound, he is one of the really good painters of our Southwest, infusing every canvas with true and authentic feeling for the place."[181]

Despite his love of the Southwest, Mexico had a siren call. Medora acknowledged that "after his initial trip to Mexico, I think his primary interest was always that country, for it contained everything he loved to paint—the mountains, the hill towns, the markets, the street life, beautiful buildings, mellow walls, and above all the peons and burros in ceaseless groupings."[182] In early April 1931, Clark organized another trip to Mexico, stopping first in Mazatlán, but with his sights set on visiting Taxco. "I look forward to each place," he wrote. "but am really aiming towards Taxco, for I believe I will find the cream there."[183]

Getting to Taxco proved more challenging than expected; in fact, the journey was harrowing. The driver of the bus was arrested for speeding (thus delaying their arrival), and roads were dangerous and unpredictable. However, Clark arrived unscathed and thrilled. "Really, this is the greatest place," he wrote. "There are several thousand houses to be seen and the Cathedral at the top, and all the houses with tile roofs, and placed at all kinds of angles. . . . All the narrow streets, being steep and winding, are always a picture."[184]

Taxco was known for its magnificent cathedral, and, according to his correspondence, Clark climbed to the church's roof and painted looking down at the vista. He also painted the church from below. "I am so pleased to have completed two big things of the Cathedral today," he wrote to Medora, "things I started a week ago that I was kind of worried about, for they are very subtle subjects in this light and full of detail. If you miss any of this, you miss the charm of the picture."[185]

He may well have been referring to *Taxco* (plate 73). The terraced landscape leads the viewer up to the church and the mountains in the background. This artfully nuanced composition bears out claims that Clark was a "technical Houdini" and "an atmospheric miracle man."[186] He returned home that summer with enough paintings for a new show that opened in the fall at Grand Central and O'Brien art galleries. Clark attended the opening in Chicago where the works were warmly received by the public and pundits. "Here is an exhibition that no one should miss," declared Eleanor Jewitt. "It is painting such as we see too little of in these days of garbled meaning and misproportioned conceits."[187]

By the early 1930s, a new phase of Clark's career had begun in the form of decorative projects, particularly those for private residences. He designed wallpaper, painted murals in dining rooms and libraries, and decorated screens. Reasons for this change of direction are not clear. A critic observed that Clark "had a thirst for experiment. Nothing must go untried."[188] On a more pragmatic note, the early 1930s was the depths of the Great Depression, and he may not have been in a financial position to reject commissions of any sort.

That said, Clark made a decision in 1933: he wanted to drive across the country. He purchased and refurbished a Chevy truck, setting out with Medora and Alson Jr. for over a year. They meandered, allowing ample time to stop and paint. Such a trip, especially in the 1930s, was nothing short of a luxury. In a period where daily struggles were often overwhelming (John Steinbeck's *Of Mice and Men,* the epic of Depression era hardship, was published in 1937), the assumption must be that Clark's finances allowed him this flexibility.

Clark and his family spent the summer of 1935 in Coronado, where the artist's work was on exhibit in the San Diego California-Pacific International Exposition. By early the following year, the artist decided to return to Europe. The Clarks had not been in Europe since the artist returned from his military service. Although his indefatigable interest in traveling has been well documented, his desire to return to Europe at this juncture is unclear. Although he was certainly not an old man, he had undoubtedly become more aware of his mortality. He had fond memories of his earlier life abroad, and, perhaps, he wished to examine Europe from the perspective of a fully mature artist.

They embarked from Los Angeles on a Holland America freighter whose route went via the Panama Canal. Clark had not visited the canal since 1914, and the prospect of actually sailing through the locks was alluring. The vessel's circuitous route eventually left them in Liverpool, England. From there they went to London, drove through Belgium and Holland, and finally arrived in Paris.

PLATE 70

Ranch in Sycamores, 1928

Oil on canvas, 26×32 inches
Collection of Robert and Nadine Hall

PLATE 71

Woman in Evening Gown, 1929

Oil on canvas on Masonite, 72 × 36 inches
Private Collection

Although forewarned that the city had changed since their last visit, Medora reported that "Paris, after almost twenty years, looked the same. From our dormers in the fifth floor of the hotel we looked out on familiar scenes, the bridges, the bookstalls, and the boats along the Seine. . . ."[189] Clark still found it irresistible. From the vantage point of their fifth-floor window, he painted images such as *Rooftops, Paris* (plate 74). Broadly brushed—with a freedom often absent from his mural commissions—the canvas confirms Clark's dedication to Impressionism. He saw Paris very much through the same youthful eyes that interpreted that magical city decades earlier. And while Clark had gained stylistic maturity and tremendous artistic experience since his last visit to Paris, he never lost faith in the basic tenets of Impressionism, although many now viewed the style as outdated.

The couple enjoyed what would be their final trip abroad but opted to return to California instead of remaining in France for the winter. Paris was still enchanting but it represented the past; a prolonged residence abroad was no longer desirable. They returned to California—happy to have been away—but equally pleased to be back.

Clark's popularity remained consistent throughout the 1930s. While the battle raged in California between the modernists and conservatives, Clark remained unaffected by the bold experiments of his peers. He was proud of his artistic heritage and technical prowess. Any doubts concerning his relevance was offset by the two generations of collectors who had avidly acquired his works. When Stendahl Art Galleries moved to its new quarters on Wilshire Boulevard (in spring 1937), a Clark exhibition was its featured opening show. Alma May Cook remarked how it was "a rarity these days, [to see] an art

exhibition devoted to the more subtle qualities of beauty of color impressions."[190] That Clark's profile at Stendahl remained consistent is a strong testament to his reputation and the ongoing commercial interest in his work.

He continued to exhibit in museums and at major exhibitions—with a one-person show at the San Diego Museum of Art in 1938—and his participation in the Golden Gate International Exposition the following year. By 1940 Clark was awarded what Medora deemed "perhaps his most satisfying exhibition": the Los Angeles County Museum presented a small but savory selection (only twenty pieces) representing his long and successful career. It included works from Panama, Chicago, Cuernavaca, France, New England, Taxco, and California. The exhibition traveled to the Crocker Gallery of Art in Sacramento, The Stanford University Museum of Fine Arts, and finally to the Haggin Museum in Stockton, California. A critic for the *Sacramento Bee* heaved a nearly audible sigh of relief when he reviewed the exhibition:

> The exhibit of Alson Clark now being shown in the E.B. Crocker Art Gallery undoubtedly will be one of the most enjoyed and popular exhibits of the season. After the tortuous rapids and whirlpools of surrealism, post-impressionism, and ventures into the abstract, the canvases of this artist are like peaceful, tree fringed pools. Here . . . is a painter who knows his business is beauty untroubled by neurotic probings, intellectual experimentation or social propaganda. . . . [191]

When America entered World War II, Clark was eager to contribute to the war effort, but he could not tolerate the exhausting pace of a factory job. Always an innovator, he organized a workshop of artists and craftsmen who produced—at a less frenetic speed—instruments for the military.[192] The end of hostilities in 1945 brought celebration but also the realization that for millions, in all parts of globe, a history of traditions and rhythms of life were forever gone. On a personal level, Clark's life also changed. He developed a heart condition and was unable to drive—a paralyzing circumstance generally for life in California and especially for one so accustomed to travel. Clark substituted his love of painting *en plein air* for figure painting in the studio. Ann Chandler Hugens was his primary model, undoubtedly sitting for works such as *In the Dressing Room* (plate 75). Motifs from his early days of figure painting (a mirror or a Louis XVI chair) remained part of his vocabulary.[193] However, the artfully composed and executed scene is illustrative, lacking the spontaneity of his earlier work.

By October 1948, Clark's health was compromised. Following four months of convalescence after a severe bout of pneumonia, he was finally allowed to return to his studio in March 1949. Medora described the day he began to paint once again as "joyous," as the artist returned to his lifelong passion. The joy was short-lived: Clark suffered a paralyzing stroke the following morning and passed away within a week. In her inimitable fashion, Medora remembered, "my son and I could only rejoice that he had in his lifetime been denied only one small week of the use of that wonderful right arm."[194] Her personal grief was mitigated because Alson's life was his art, and the inability to practice his craft would have been a tragedy far greater than death.

PLATE 72

Flaming Bushes, 1930

Oil on canvas, 29×31 inches
Collection of Dana A. Gemmingen

PLATE 73

Taxco, c. 1931

Oil on canvas, 26×32 inches

Rowe Family Trust

Conclusion

News of Clark's death quickly circulated.[195] Condolences poured in from all corners, but perhaps some of the most poignant responses were from lifelong friends on the East Coast—the artists with whom Clark had shared his youth in Paris. Lawton Parker's second wife spoke for the couple: "Of all the people I have met since knowing Lawton, Alson is the one friend he has spoken of constantly. I have heard how popular he was in Paris. . . . Of all Lawton's friends, Alson was the most loved, not only because of his integrity as a good artist, but of more importance was the fact that he was a humorous, generous, kind, and interesting person."[196]

Clark's focus was always his art, however, he never refused a game of billiards, played golf throughout his life, and installed a badminton court in Pasadena when the game was little known in America. He traveled across the globe, and each new place inspired works that were appreciated by both art connoisseurs and the general public. Clark's lifetime was framed by the country's centennial at one end and the beginning of the Cold War on the other—an era characterized by enormous change in all areas.

It was never Clark's intention to push the envelope of artistic experimentation. He remained a devotee of Impressionism throughout his life, and made no apologies for his convictions. In the context of what became the parameters for critical appreciation after World War II—especially given the mandate from critics and collectors for constant innovation— Alson Clark's paintings slowly slipped into obscurity after his death. Retrospectives were held at the Pasadena Art Institute (1951), the La Jolla Art Center (1953), and O'Brien Galleries (1954). In 1960,

Terry De Lapp Galleries in Los Angeles held a small exhibition of his work. The following year, Hirschl & Adler Galleries in New York also mounted a small show. It took nearly ten years for a significant group of Clark's paintings to be exhibited at Robert Schoelkopf Gallery in New York, and until 1983 for Petersen Gallery in Los Angeles to publish the first comprehensive study of the artist.

Clark was described as an artist "sensitive to beauty."[197] Larger philosophical issues of beauty aside, this is probably an apt characterization. To be sure, Clark's notion of beauty—often in the form of decaying walls, panoramic rooftop views, bridges, desert vegetation or scenes of historical California— was highly personal. Yet he painted with optimism and a joie de vivre that was contagious. His works are neither simplistic nor fraught with emotional angst: that was never part of his agenda. Alson Clark spent a lifetime painting the world around him, and he invited the public to share in his journeys.

PLATE 74

Rooftops, Paris, 1936

Oil on canvas, 22 × 18½ inches

Collection of the McNay Art Museum, San Antonio, Gift of Mrs. Alson S. Clark

Alson Clark

PLATE 75

In the Dressing Room, 1947

Oil on canvas, 28×24 inches
Collection of Terry and Paula Trotter

Notes

1. For example, see Richard Guy Wilson et al., *The American Renaissance, 1876–1919* (Brooklyn: The Brooklyn Institute of Arts and Sciences, 1979).

2. Although much of Clark's life is described through letters and diaries (beginning in 1889), little primary source material exists regarding his childhood. For that information, we are dependent upon the recollections of his wife, Medora, preserved in interviews in 1956 and 1957 as part of the Oral History Project of the Archives of American Art. A copy of the transcript interview of Medora Clark, "Biography of Alson Skinner Clark," by Margaret Truax Hunter, Part I (1956) and Part II (1957), is in the Archives of American Art, Smithsonian Institution, Washington, D.C. (hereafter Hunter, Part I or Part II). Although observations and perceptions regarding Alson remain significant, specific places and dates can be inaccurate. This quotation is from Hunter, Part I, p. 1.

3. Ibid., p. 2.

4. Clark's transcript was obtained from Lori Daniels, Academic Records Specialist, Registrar's Office, The School of The Art Institute of Chicago. Clark's diaries (hereafter Clark Diaries) are part of the unmicrofilmed Alson Skinner Clark Papers, Archives of American Art, Smithsonian Institution, Washington, D.C. (hereafter ACP).

5. Medora recalled: "The instructor adamantly maintained that Alson should remain in casts . . . and followed up his ultimatum by announcing that he considered Alson Clark completely without talent and his wisest council would be to abandon art." See Hunter, Part I (note 2), p. 6.

6. The joint diary of Sarah Clark, Amelia Baker, and Alson Clark (1896–97) is owned by Ellen Clark and was generously loaned to the author. References to that diary hereafter will be known as Ellen Clark Family Archives (ECFA). See Sarah Clark diary entry, November 3, 1896, ECFA.

7. For information on the league, see H. Barbara Weinberg, "Frieseke's Art Before 1910," in *Frederick Carl Frieseke: The Evolution of an American Impressionist* (Savannah: Telfair Art Museum with Princeton University Press, 2001), p. 54. See also John C. Van Dyke, "The Art Students League of New York," *Harper's New Monthly Magazine* 83 (October 1891), pp. 688–700.

8. Sarah Burns, *Inventing the Modern Artist: Art and Culture in the Gilded Age* (New Haven: Yale University Press, 1996), pp. 22–23. In the extensive literature on Chase, see, for example, Ronald Pisano, *William Merritt Chase: A Leading Spirit in American Art* (Seattle: Henry Art Gallery, 1983); Barbara Gallati, *William Merritt Chase* (New York: Harry N. Abrams, Inc. with the National Museum of American Art, 1995); Barbara Gallati, *William Merritt Chase: Modern American Landscapes* (New York: Brooklyn Museum in association with Harry Abrams, Inc., 1999).

9. Hunter, Part I (note 2), p. 8.

10. Chase stated: "Absolute originality in art can only be found in a man who has been locked in a dark room from babyhood. . . . Since we are dependent upon others, let us frankly and openly take in all that we can. . . . The man who does that with judgment will produce an original picture that will have value." See "From a Talk with William Merritt Chase with Benjamin Northrup of the Mail and Express," *The Art Amateur* 30, 3 (February 1897), p. 77.

11. Alson diary entries, February 3, March 6, and March 10, 1897, ECFA (note 6).

12. Clark had a sister, Mary Emily (Mamie), who passed away in 1871. "Comfort Island," in particular, suggests a happier era, when Mamie was still alive. Information regarding the island's name was provided by Deborah Clark, the artist's grandniece. I am grateful to Ms. Clark for all of her assistance.

13. For information on Chase and Shinnecock, see D. Scott Atkinson, "Shinnecock and the Shinnecock Landscape," in *William Merritt Chase, Summers at Shinnecock, 1891–1902* (Washington, D.C.: National Gallery of Art, 1988); Katherine Cameron, "The South Fork: Southampton, Shinnecock Hills, and William Merritt Chase," in *The Artist as Teacher, William Merritt Chase and Irving Wiles* (East Hampton, New York: Guild Hall Museum, 1994); H. Barbara Weinberg, Doreen Bolger, and David Park Curry, *American Impressionism and Realism: The Painting of Modern Life, 1885–1915* (New York: The Metropolitan Museum of Art and Harry N. Abrams, 1994), pp. 105–17; Deborah Epstein Solon and Will South, *Colonies of American Impressionism: Cos Cob, Old Lyme, Shinnecock, and Laguna Beach* (Laguna Beach, California: Laguna Art Museum, 1999).

14. Clark noted that he and Ullman "hired a rig and drove to Chase—he showed us all the stuff in the studio and had a delightful time." See Clark Diaries, June 22, 1897, ACP (note 4).

15. Ibid., June 30, 1897.

16. Clark to Amelia Baker, November 4, 1897, Deborah Clark Family Archives. Amelia Baker played a key role in Alson's life before he married Medora (although they were never a love interest). He kept up a consistent correspondence with her even after his marriage. The letters are now in the possession of Deborah Clark, who graciously shared them with the author (hereafter DCFA).

17. Clark Diaries, January 30, 1898, ACP (note 4).

18. Clark to Baker, February 22, 1898, DCFA (note 16).

19. Ibid., March 1898.

20. I am grateful to Professor Pierre Ullman, the artist's son, for information on the relationship between Clark and his father.

21. Clark Diaries, June 14. 1898, ACP (note 4).

22. Clark to Baker, July 28, 1898, DCFA (note 16).

23. Hunter, Part I (note 2), p. 10.

24. Clark Diaries, November 2, 1898, ACP (note 4).

25. Clark to Baker, November 20, 1898, DCFA (note 16).

26. Clark Diaries, November 24, 1898, ACP (note 4).

27. The Académie Julian was founded by the painter Rudolphe Julian. As opposed to the Ecole des Beaux-Arts, entrance to Julian's did not require an examination. Students paid a nominal fee to work under the tutelage of artists such as William Bouguereau, Benjamin Constant, and Gustave Boulanger. See Lois Marie Fink, *American Art at the Nineteenth-Century Paris Salons* (Cambridge, England: University of Cambridge, 1990).

28. Clark Diaries, November 26 and 28, 1898, ACP (note 4).

29. For a fascinating interpretation of Whistler, see Burns (note 8), p. 243.

30. Clark to Baker, December 20, 1898, DCFA (note 16).

31. Jean Stern noted that models included a woman called Pauline; a young Italian woman named Louise; and Miss Whitcomb, a model he shared with Will Howe Foote. See Stern, "Alson Clark: An American at Home and Abroad," in *California Light, 1900–1930* (Laguna Beach, California: Laguna Art Museum, 1990), p. 115.

32. Clark to Baker, February 7 and January 6, 1899, DCFA (note 16).

33. Ibid., Clark to Baker, February 2, 1899.

34. Ibid., Clark to Baker, March 24, 1899.

35. Ibid., Clark to Baker, April 11, 1899.

36. Medora recounted that Clark's parents were horrified at the suggestion of an operation—appendectomies were rare at the time. Alson was firm and eventually had his appendix removed, making the front page of the leading Chicago newspaper. Hunter, Part I (note 2), p. 16.

37. Unidentified newspaper clipping, 1901, ACP (note 4).

38. For information on Frieseke, see Nicolas Kilmer et al., *Frederick Karl Frieseke: The Evolution of an American Impressionist* (Savannah: Telfair Art Museum with Princeton University Press, 2001).

39. See David Sellin, "Frieseke in Le Pouldu and Giverny: The Black Gang and the Giverny Group," in ibid., pp. 74–75.

40. Hunter, Part I (note 2), p. 17.

41. Clark Diaries, January 10, 20, and 23, 1902, ACP (note 4).

42. Stern (note 31), p. 117. For information on The Eight, see Elizabeth Milroy and Gwendolyn Owens, *Painters of a New Century: The Eight & American Art* (Milwaukee: Milwaukee Art Museum, 1991).

43. Clark Diaries, March 9, 1902, ACP (note 4).

44. Hunter, Part I (note 2), p. 18.

45. Medora Clark Diaries, March 10, 1902, ACP (note 4).

46. Ibid., "Pattison's Art Talk," unidentified newspaper clipping, [1902]; *Chicago Tribune,* unidentified newspaper clipping, 1902; *Chicago Times Herald,* unidentified newspaper clipping in ACP (note 4).

47. Medora claimed that Talcott was a Forty-Niner, and one of the founders of the First National Bank of Chicago. See Hunter, Part I (note 2), p. 19. For genealogical information on the Skinner and Clark families, the author is grateful to Edwin H. Clark, the artist's grandnephew.

48. The mural remains at the Mancel Talcott School, 1840 West Ohio Street, Chicago. The author acknowledges Mrs. Marcella Richman for her assistance in identifying the work.

49. The nuptials were announced in "Happy Wedding Ceremonies," *The Watertown Daily Times,* October 1, 1902. The author acknowledges Joe Sizoo for providing this newspaper article.

50. Hunter, Part I (note 2), p. 20.

51. Apparently before Frieseke married, the Clarks provided him with "familial stability and comradeship. The three shared meals and evenings of Parcheesi or bezique." See Kilmer (note 38), p. 25.

52. Hunter, Part I (note 2), p. 26.

53. See Jean Stern, *Alson S. Clark* (Los Angeles: Petersen Publishing Company, 1983), p. 16. He suggests that they traveled with Lawton Parker, Frederick Frieseke, and Guy Rose. However, Medora wrote that they traveled with a "bachelor friend of Alson's," not specifying who that was. See Hunter, Part I (note 2), p. 26. It is possible that the group included the three artists, as David Sellin (note 39), p. 77, states that in 1903 Frieseke declined Richard Miller's invitation to teach with him in Holland, looking into the "prospect of joining Clark, Parker, and Guy Rose on a Breton excursion. . . . "

54. Clark to Baker, March 25, 1904, DCFA (note 16). It appears that Amelia was acting as a conduit for his work in America, making certain that paintings were properly shipped to various exhibitions.

55. Clark exhibited at the Society of American Artists every year between 1902 and 1906. His entries included *The Black Race,* 1902; *A Watering Place,* 1903; *Playground in the Luxembourg,* 1904; *The Bridge Builders,* 1905; and *The Coffee House,* 1906. I am grateful to Phil and Marian Kovinick for this information.

56. Hunter, Part I (note 2), p. 32.

57. See Peter Falk, *Annual Exhibition Record of the Art Institute of Chicago, 1888–1950* (Madison, Connecticut: Soundview Press, 1990).

58. See Stern (note 31), p. 119. Stern also examines in detail the Whistlerian influence on another early portrait, *The Green Parasol* (1906, Private Collection).

59. For information on Macbeth, see Gwendolyn Owens, "Art and Commerce: William Macbeth, The Eight, and the Popularization of American Art," in Milroy and Owens (note 42).

60. Clark to Macbeth, October 27, 1905. See Macbeth Gallery Records, Archives of American Art, Smithsonian Institution, reel NMc5, frame 849. I thank Phil and Marian Kovinick for information from the Macbeth Gallery Records.

61. Ibid., Clark to Macbeth, January 1, 1906, reel NMc5, frame 852. Stern notes that when the sale of Chase's estate was held between May 14 and 17, 1917 (American Art Galleries), two paintings by Clark, *Urban Landscape* and *Watertown in Winter,* were still in Chase's personal collection. Stern (note 53), p. 53, n. 3.

62. See "Exhibition of Paintings by Alson Skinner Clark," The Art Institute of Chicago, January 2–21, 1906. I am grateful to Lynn Maphies, Department of Modern and Contemporary Art, The Art Institute of Chicago, for furnishing a photocopy of the catalogue. Stern (note 31), p. 118, incorrectly notes that fifty-seven paintings were included in the exhibition, and that they were primarily scenes of Brittany. The catalogue of the exhibition includes forty-five pictures, and the subjects were varied.

63. "Art Exhibitions Next Week," *Chicago Post,* January 6, 1906, clipping file, Ryerson and Burnham Libraries, The Art Institute of Chicago. I am especially grateful to Peter Blank, Reference Librarian, for citations and copies of reviews from Clark's one-person 1906 exhibition in Chicago. For additional reviews, see "The Yellow Scarf by Alson S. Clark on Exhibition at the Art Institute," *Chicago Record Herald,* January 14, 1906, clipping file, Ryerson and Burnham Libraries, The Art Institute of Chicago.

64. Ibid., Harriet Monroe, "The Glasgow Painters and Others," *Chicago Examiner,* January 3, 1906.

65. Hunter, Part I (note 2), p. 35.

66. Clark to Macbeth, January 16, 1906, Macbeth Gallery Records (note 60), reel NMc5, frame 853.

67. See Elizabeth Milroy, "Modernist Rituals and the Politics of Display," in Milroy and Owens (note 42), p. 26.

68. See Charles Caffin, "Current Pennsylvania Academy Exhibition," *Brush and Pencil* 19 (January 1907), ACP (note 4). While Caffin does not review the painting, he does note that "Philadelphians will be glad of an opportunity of seeing Alson Skinner Clark's *Coffee House,* which was awarded the Cahn Prize at the Chicago Institute last year."

69. After a few falls, he apparently devised a technique that lessened the amount of time he spent in the snow rather than on it. Hunter, Part I (note 2), p. 38.

70. For an excellent account of Birge Harrison, see Andrea Husby, "Birge Harrison: Artist, Teacher and Critic," Ph.D. dissertation, Graduate Center of the City of New York, 2003. I am grateful to Dr. Husby for her assistance.

71. See, for example, Harrison's *Floating Ice,* c. 1906–10 (California Club); *Sunset from Quebec* (Private Collection); and *The Lower Town, Quebec,* c. 1906–10 (unlocated).

72. Clark to Macbeth, December 18, 1906, Macbeth Gallery Records (note 60), reel NMc5, frame 858.

73. Hunter, Part I (note 2), p. 43.

74. "Alson S. Clark's Paintings," *Bulletin of the Detroit Museum of Art* 3 (April 1909). See Archives of American Art, Smithsonian Institution, The Detroit Institute of Arts Scrapbooks, reel D12, frame 234.

75. Clark to Macbeth, Macbeth Gallery Papers (note 60), March 13, 1909, reel NMc5, frame 864. Clark was undoubtedly referring to one of two pictures included in The Pennsylvania Academy of the Fine Arts exhibition for 1909: *Market Place: Quebec* (no. 660) or *Quebec in Winter* (no. 662).

76. Medora claimed that according to a friend at the American Embassy, only fifty-five Americans registered to be in the country that summer. See Hunter, Part I (note 2), p. 52. Whether or not this is precisely accurate, it is clear that number of Americans in countries such as France, Italy, Germany, and Holland exceeded those in Spain.

77. Ibid., p. 45.

78. See Stern (note 31), p. 121.

79. Travel conditions during these frequent journeys were often less than ideal. "We were always crossing back and forth in the winter months to take advantage of the cheaper rates," recalled Medora. "The trips were rugged and frigid, and ocean-liners still after all these years mean to me ice-covered bows." Hunter, Part I (note 2), p. 51.

80. Stern (note 31), p. 127.

81. William H. Gerdts, *Monet's Giverny* (New York: Abbeville Press, 1993); see also Gerdts, *Lasting Impressions: American Painters in France, 1865–1915* (Evanston, Illinois: Terra Foundation for the Arts, 1992).

82. An interesting study on Giverny, with an emphasis on these painters, is Bruce Weber, *The Giverny Luminists: Frieseke, Miller, and Their Circle* (New York: Berry-Hill Galleries, 1995).

83. Medora Clark Diaries, August 28, 1910, ACP (note 4).

84. "Prices of everything have been adjusted to the American pocket." Arthur B. Frost to Augustus Daggy, September 19, 1908, in Gerdts, *Monet's Giverny* (note 81), p. 157, n. 3.

85. Medora Clark Diaries, October 27, 1910, ACP (note 4).

86. Simon is best known as a color-etcher. Clark and Simon became friendly in Paris, where Simon assisted Clark in learning the elements of color etching, and Clark helped Simon to use a lithographic press. See Stern (note 53), p. 21. Clark was an accomplished lithographer and etcher, however, these works need to be thoroughly explored in a separate study.

87. Clark to Medora, January 18 and 22, 1912, ACP (note 4).

88. For information on Martha Walter, see William H. Gerdts, "Martha Walter: A Retrospective," *American Art Review* 14

(October 2002), pp. 150–61; for Alice Schille, see Gerdts, *Alice Schille* (New York: Hudson Hills Press, 2001).

89. Harriet Monroe, "Clark's Art Gains in Style and Aim," *Chicago Daily Tribune,* January 19, 1913, p. 4.

90. David McCullough, *The Path Between the Seas: The Creation of the Panama Canal* (New York: Simon and Schuster, 1977), p. 543. To date, McCullough's work is the most exhaustive examination of the building of the Panama Canal.

91. Ibid., p. 11.

92. The project cost over $375,000,000. The total spoil excavated in the Canal Zone would have formed a pyramid 4,200 feet high (or more than seven times the height of the Washington Monument), and a total of over 44,000 individuals worked on the project. See ibid., p. 529. For the French effort, see pp. 220–70. The canal was almost constructed in Nicaragua, and for a fascinating account of the political jockeying behind the final decision, see pp. 329–402.

93. Two fortunate sets of circumstances occurred simultaneously. Although the couple arrived without reservations, they acquired accommodations at the Hotel Tivoli through its general manager, who was an acquaintance. See Stern (note 53), p. 25. Additionally, Clark coincidentally knew Goethal's daughter-in-law, who, once contacted, arranged introductions. See Hunter, Part I (note 2), p. 78.

94. Clark to Sarah Clark, March 27, 1913, ACP (note 4).

95. Ulrich Keller, *The Building of the Panama Canal in Historic Photographs* (New York: Dover Publications, 1983), p. 43.

96. McCullough (note 90), p. 591.

97. Medora Clark, "The Zone from a Woman's Point of View," p. 10. Typed manuscript, ACP (note 4).

98. Jim Crow laws flourished in the Canal Zone, with a tremendous discrepancy in the living conditions and death rates between black and white workers. See McCullough (note 90), pp. 574–88.

99. Clark wrote to his mother, "Yesterday I went over and secured passage for Panama to sail September 9th from Antwerp. . . . I think that we really must go to Panama again and try to 'make a killing' with a good show. I want some pictures with water in the Canal, and I guess that will do it. . . ." Clark to Sarah Clark, August 5, 1913, ACP (note 4).

100. Hunter, Part I (note 2), p. 85.

101. John Trask to Clark, June 24, 1913, ACP (note 4).

102. See, for example, William H. Gerdts and Will South, *California Impressionism* (New York: Abbeville Press, 1998), pp. 188–200.

103. Works at the Art Institute included *Panama Street; Morning, Ancon Hill, Panama;* and *Gold Hill Panama.*

104. Lena M. McCauley, *Chicago Evening Post,* November 25, 1913, Archives of American Art, Smithsonian Institution, Vose Galleries of Boston, reel 4593, frame 73. Courtesy of Marian and Phil Kovinick.

105. "Fine Arts," *Boston Transcript,* January 15, 1914, Vose Galleries of Boston, reel 4593, frame 538, in ibid.

106. Clark to Sarah Clark, August 2, 1914, ACP (note 4).

107. Medora supplied an informative, often moving, account of the events. They traveled on a ship to Le Havre—through streams of Belgian refugees—finally sailing on an ill-equipped vessel for America. As they pulled into New York harbor, Medora remembered: "Alson and I always loved to see the Statue of Liberty come into view, and this time, after the long solitary ten-day crossing, it was hard to refrain from weeping as her slow emergence from the mist took on a new significance." Hunter, Part I (note 2), p. 94.

108. For a listing of the paintings, see *Catalogue of the Department of Fine Arts, Panama-Pacific International Exposition* (San Francisco: The Wahlgreen Company, 1915), p. 12.

109. Eugen Neuhaus, *The Galleries of the Exposition: A Critical Review of the Painting, Statuary and Graphic Arts in the Palace of Fine Arts at the Panama Pacific International Exposition* (San Francisco: The Wahlgreen Company, 1915), p. 83.

110. Lena M. McCauley, "Art and Artists," *Chicago Evening Post,* September 28, 1916, ACP (note 4); and "Art," *Chicago Tribune,* October 3, 1916.

111. Medora to Sarah Clark, April 2, 1913, ACP (note 4).

112. The West Point Museum, United States Military Academy, owns twelve of these works. I am grateful to Curator David Reel for information on these paintings. For additional information, see the exhibition checklist "Art of the Panama Canal: A Selection of Art and Artifacts Commemorating the Transfer of the Panama Canal from the United States to the Republic of Panama," The West Point Museum, United States Military Academy, [2000]. For a review of Lie's paintings, see "American Painter Wins Big Pittsburgh Prize," *Saturday Night,* May 9, 1914, Archives of American Art, The Detroit Institute of Arts Scrapbooks, reel D13, frame 531.

113. See Joseph Pennell, *Pictures of the Panama Canal* (Philadelphia: J. B. Lippincott & Co., 1912). See also Pennell, *Pictures of the Wonder of Work* (Philadelphia: J. B. & Co., 1916).

114. The most comprehensive study of Charleston's art and culture is Martha Severens, *The Charleston Renaissance* (Spartanburg, South Carolina: Saraland Press, 1998).

115. Hunter, Part II (note 2), p. 14.

116. Severens (note 114), p. 47.

117. Heyward once lived across the street from the complex, transforming it into the primary setting for his novel and later the Broadway production *Porgy and Bess.* See ibid., p. 73. Its popularity ultimately led to Cabbage Row's restoration and gentrification. Clark's images stand as a record of Charleston history that was ultimately rewritten.

118. Clark wrote to Medora that evening, "We have sailed . . . and I know you know it, but you were a brick as you always are in any emergency. I will tell you in every letter that I adore you, for I do more and more, but tonight I was making a brave fight to keep up and know that you are doing the same." See ACP

(note 4), November 3, 1917. The Clarks kept up a prodigious correspondence during the war, often writing on consecutive days and numbering the letters.

119. Ibid., Clark to Medora, March 4, 1917.

120. Hunter, Part II (note 2), p. 19.

121. Ibid., p. 26.

122. Frederick Roland Miner, "California—The Landscapists Land of Heart's Desire," *Western Art* 2 (June/August 1914), p. 31.

123. Hunter, Part II (note 2), p. 28.

124. Ibid., p. 30.

125. See Jean Stern et al., *Romance of the Bells* (Irvine, California: Irvine Museum, 1995).

126. For contemporary articles on the missions, see Laura Bride Powers, "The Missions of California," *The Californian*, September 1892, pp. 547–56; John T. Doyle, "The Missions of Alta California," *Century* 42 (January 1891), pp. 289–402; Vernon Selfridge, *The Miracle Missions* (Los Angeles: Grafton Publishing, 1915).

127. Powers (note 126), p. 547. For an excellent assessment of the mission as a symbol, see James Rawls, "The California Mission as Symbol and Myth," *California History,* Fall 1992, pp. 342–61.

128. Clark Diaries, May 11, 1919, ACP (note 4).

129. Clark purchased the land from Edward Butler, a highly successful Chicago businessman and art collector whose hobby was painting. Butler was one of Clark's major patrons (based on information in the Clark notebooks), and he occasionally studied with the artist in Paris. Butler was making a large real estate purchase in Pasadena, and offered the artist a parcel of land. See Hunter, Part II (note 2), pp. 41–42.

130. For Old Lyme, see Jeffrey Andersen, Susan Larkin, et al., *Connecticut and American Impressionism* (Storrs, Connecticut: University of Connecticut with the William Benton Museum of Art, 1980); Jeffrey Andersen, William H. Gerdts, et al., *En Plein Air* (Easthampton, New York: Guild Hall of East Hampton; Old Lyme: Old Lyme Historical Society, 1989); Solon and South (note 13).

131. Clark Diaries, January 1, 1920, ACP (note 4).

132. Hunter, Part II (note 2), p. 44.

133. *The Chicago Evening Post,* February 7, 1920, ACP (note 4).

134. Clark Diaries, August 31, 1920, in ibid.

135. The school's impressive faculty included Conrad Buff, Lorser Feitelson, and Arthur Millier. For more on the school, see "Miss Stickney is Donor of Building." *Pasadena Star News,* July 31, 1914, p. 4; "New Steps Taken to Make Pasadena Art Center," *Pasadena Star,* May 9, 1914, p. 1; "Art School Registering Students," *Pasadena Star,* October 5, 1914, p.14. See also Stickney Memorial Art School Clipping Files, Pasadena Public Library. I am grateful to Natasha Kahn, Research Librarian, Pasadena Public Library.

136. "The younger generation and the students of the Stickney School in Pasadena are fortunate to have so valuable an influence as Alson Clark." Elizabeth Bingham, "Art Exhibitions and Comments," unidentified newspaper clipping, ACP (note 4).

137. Clark Diaries, February 1921, in ibid.

138. Ibid., August 10, 1921.

139. Hunter, Part II (note 2), p. 56.

140. Ibid., p. 58.

141. "Brief Commentary on Various Events," *Los Angeles Times,* March 15, 1923, part 3, p. 31.

142. "Art Notes," *Laguna Life,* June 23, 1923, p.1.

143. Clark to Medora, [June] 1923, ACP (note 4).

144. Ibid., June 9, 1923.

145. For information on Cuernavaca and Mexico City, I am indebted to Pat Morgan.

146. Clark to Medora, June 16, 1923, ACP (note 4).

147. "Paintings of Old Mexico Now Exhibited at Park Gallery," *San Diego Union,* August 5, 1923, in ibid.

148. Hunter, Part II (note 2), p. 59.

149. *Christian Science Monitor,* November 26, 1923, ACP (note 4).

150. "Alson Clark, Globe-Trotter Artist," unidentified newspaper clipping, c. 1923, in ibid.

151. Sonia Wolfson, "Clark's Brush Rich in Beauty and Grace," unidentified newspaper clipping, c. 1923, in ibid.

152. Antony Anderson, "Of Art and Artists," *Los Angeles Times,* January 7, 1923, part 3, pp. 19, 37.

153. "Southern California Scenery," *Land of Sunshine,* August 1, 1894, p. 64.

154. Eloise J. Roorhas, "The Indigenous Art of California: Its Pioneer Spirit and Vigorous Growth," *The Craftsman,* August 1912, p. 489.

155. See Will South, *Stanton-Macdonald Wright and Synchromism* (Raleigh: North California Museum of Art, 2001).

156. Medora Clark, "European Landscape Versus California," *California Southland,* ACP (note 4).

157. Clark's notebooks document that his work could be found, for example, in collections in Pennsylvania, New Jersey, New York, Massachusetts, and Illinois.

158. For Butler's biography, see *The National Cyclopaedia of American Biography* (New York: James T. White and Company, 1903), volume 10. I am grateful to Phil and Marian Kovinick for information on Butler.

159. See the following obituaries: "E. B. Butler Summoned by Death," *Pasadena Star News,* February 21, 1928, part 2, p. 15; "Edward Butler, Merchant and Art Patron, Dies," *Chicago Daily Tribune,* February 21, 1928; "Merchant of Chicago Dies Here," *Los Angeles Times,* February 21, 1928, p. 17.

160. See *Bulletin of The Art Institute of Chicago* 3 (January 1912), p. 36. After Butler's death, the Art Institute organized an exhibition of the Inness paintings he had donated. See *The Edward B. Butler Collection of Paintings by George Inness 1825–1894* (Chicago: The Art Institute of Chicago, 1930). The provenance of various paintings is particularly noteworthy, with many formerly in the collections of several influential American art patrons such as Thomas B. Clark or William T. Evans.

161. Hunter, Part II (note 2), p. 41. For Butler's exhibition records, see Falk (note 57), p. 177.

162. See Hunter in ibid., p. 62.

163. The theater is now a historical landmark. The curtain still hangs above the stage; however, it is made of asbestos and for health reasons cannot be raised or lowered. I am grateful to Ellen Bailey, Archivist, The Pasadena Playhouse.

164. Hunter, Part II (note 2), p. 62.

165. Johnson's curtain depicted the George Donner party crossing Donner Lake. Hanging on either side were companion pieces, *The Miners* and *The Indians.* The subject of the fourth mural was California's first theater, opened in 1849.

166. Alce Ann Clark Cole, a member of the Clark family, took these photographs in 1973. They were intended as a lasting tribute to the wonderful Victorian home and its fascinating history. I am indebted to Edwin (Toby) Clark for sharing these family treasures.

167. An invitation from the historical committee suggested "it is planned to make the Carthay Circle Theatre a museum of California material. An invitation is extended to all lovers of the Golden State who have relics worthy of presentation," and further promising that the theater was a "fireproof structure." ACP (note 4).

168. Hunter, Part II (note 2), p. 65.

169. "Saturday Night," unidentified newspaper clipping, May 22, 1926, ACP (note 4).

170. Alma May Cook, "Colorful History of Early Life Vividly Pictured," unidentified newspaper clipping, in ibid.

171. For a brief explanation of mural painting in California pre-1930s, see Nancy Moure, "Mural Painting to 1960," in *California Art: 450 Years of Painting and Other Media* (Los Angeles: Dustin Publications, 1998). For reviews of the Los Angeles Public Library murals, see [M]abel Urmy Sears, "The Herter Murals in Los Angeles," Ferdinand Perret Research Library of the Arts and Affiliated Sciences, Archives of American Art, Smithsonian Institution, reel 3857, frame 1025; "Albert Herter Murals, History Room, Los Angeles City Public Library," in clipping file Department of Art & Music, Los Angeles Public Library; "Beach Sunlight Draws Cornwell Here for Study," *The Miami Sun,* part 3, January 6, 1928, in Dean Cornwell Papers, Archives of American Art, Smithsonian Institution, reel 3782, frame 911. I am grateful to Phil and Marian Kovinick, and David Gonella, Reference Librarian, Los Angeles Public Library, for the above citations.

172. "Chicago Art Notes," *Christian Science Monitor,* March 25, 1925, ACP (note 4).

173. In the late 1920s, the company changed its name from the Wadsworth-Howland Paint Company to the Jewel Paint Company.

174. Dan Murphy to Clark, April 1927 and August 19, 1927, ACP (note 4).

175. The paintings are still extant at the bank and well preserved.

176. "The Editor's Own Page," unidentified newspaper clipping, September 1929, ACP (note 4).

177. Bartering was not uncommon, even before the Great Depression. On different occasions, Clark bartered for a grand piano, a group of frames from a cabinetmaker, a cache of decorative tiles, and a life contract for two pounds of chocolate a month from one of Chicago's best-known candymakers. Hunter, Part II (note 2), pp. 90–91.

178. Ibid., p. 71. I am grateful to William Horton for graciously providing information on the California Club.

179. Ibid.

180. "New California Club Building Opens Today," *Los Angeles Examiner,* August 25, 1930, pp. 3, 6.

181. Merle Armitage, "Topics of the Town," unidentified newspaper clipping, March 17, 1930, Archives of American Art, Smithsonian Institution, reel 3854, frame 1059, in Perret Papers (note 171). Armitage was a famed critic, impresario, and designer in Los Angeles. He counted among his friends artists such as Pablo Picasso, Paul Klee, and Wassily Kandinsky. Armitage also holds the distinction for coining the term "Eucalyptus School," a phrase that became a derogatory reference to Impressionist painters in California. See "Eucalyptus School," *Los Angeles Times,* September 16, 1928.

182. Hunter, Part II (note 2), p. 72.

183. Clark to Medora, April 6, 1931, ACP (note 4). It appears that Clark was accompanied by his friend Carlton Swift, who was studying and sketching the indigenous flora. See "Pasadenan Painting Old Mexico Scenes," *Pasadena Star-News,* May 6, 1931.

184. Clark to Medora, April 18, 1931, ACP (note 4).

185. Clark to Medora, April 27, 1931, in ibid.

186. Sonia Wolfson, "Topics of the Town," July 1931, in Archives of American Art, Smithsonian Institution, reel 3854, frame 1062 in Perret Papers (note 171).

187. Eleanor Jewitt, "Exhibition of Alson Clark Canvases Opens Today in Chicago," *Chicago Tribune.* November 9, 1931, ACP (note 4). See also Tom Vickerman, "Sunlight Streams of Alson Clark's Mexico Paintings," *Chicago Post,* November 10, 1931.

188. Madge Clover, "Saturday Night," September 3, 1932, unidentified newspaper clipping, Archives of American Art, Smithsonian Institution, reel 3854, frame 1017, in Perret Papers (note 171).

189. Hunter, Part II (note 2), p. 86.

190. Alma May Cook, "News of the Art World," *Los Angeles Evening Herald and Express,* April 17, 1937, Archives of American

Art, Stendahl Art Galleries Papers, reel 2717, frame not legible. I am grateful to Phil and Marian Kovinick for this citation.

191. "Clark Exhibit at Crocker," *The Sacramento Bee* [February 1941], ACP (note 4).

192. Hunter, Part II (note 2), p. 96.

193. Paula and Terry Trotter have provided letters from Ann Chandler Hugens confirming that she was Clark's model. I am grateful to the Trotters for their assistance.

194. Hunter, Part II (note 2), p. 98.

195. See obituaries in *The New York Times,* March 24, 1949; *Pasadena Star News,* March 22, 1949; *San Diego Union,* March 23, 1949.

196. Mrs. Lawton Parker to Medora Clark, April 7, 1949, ACP (note 4).

197. "Alson Clark Exhibit at Crocker, *The Sacramento Bee* [February 1941], in ibid.

PLATE B

Arroyo Seco from the Studio, 1921

Oil on canvas, 35 ×46 inches
Spanierman Gallery LLC, New York

Catalogue of the Exhibition

PLATE A. *An Autumn Afternoon, Giverny,* c. 1910
Oil on canvas, 25 × 31 inches
The Redfern Gallery, Laguna Beach, California

PLATE 1. *Early Nude,* c. 1898
Oil on canvas, 24 × 15 inches
DeRu's Fine Arts, Laguna Beach, California

PLATE 2. *Landscape near Le Pouldu, France,* c. 1900
Oil on canvas, 16 × 13 inches
DeRu's Fine Arts, Laguna Beach, California

PLATE 3. *The Violinist,* c. 1901
Oil on canvas, 26 × 22 inches
Huntington Library, Art Collections and Botanical Gardens,
San Marino, California
Gift of Alson Clark, Jr.

PLATE 4. *The Black Race,* 1902
Oil on canvas, 30 × 38 inches
Collection of Robert and Susan Ehrlich

PLATE 5. *From Our Window, Paris,* 1903
Oil on canvas, 25 × 31 inches
Collection of W. Donald Head/Old Grandview Ranch

PLATE 6. *In the Fog,* 1903
Oil on canvas, 10½ × 13¾ inches
Collection of Mr. and Mrs. Kerry McCluggage

PLATE 7. *A Breton Homestead,* c. 1903
Oil on canvasboard, 9½ × 13 inches
DeRu's Fine Arts, Laguna Beach, California

PLATE 8. *The Bridge Builders,* 1904
Oil on canvas, 30 × 38 inches
Collection of Mr. and Mrs. Anthony Podell

PLATE 9. *The Forest of Masts, Genoa,* 1904
Oil on board, 12½ × 15¾ inches
The Buck Collection, Laguna Hills, California

PLATE 10. *Carson Pirie Scott Department Store,* 1905
Oil on canvas, 24½ × 31½ inches
Collection of Robert and Nadine Hall

PLATE 11. *The Necklaces (Les Colliers),* 1905
Oil on canvas, 38¾ × 30⅛ inches
Collection of Earl and Elma Payton

PLATE 12. *Grey and Gold,* 1906
Oil on canvas, 17 × 20 inches
Collection of Peter B. Clark Family Trust

PLATE 13. *Pushing Through the Ice,* 1906
Oil on Masonite, 18 × 21½ inches
Spanierman Gallery LLC, New York.

PLATE 14. *Winter Industrial Landscape on the Chicago River,* 1906
Oil on canvas, 26 × 32 inches
Collection of Saul A. Fox
Photo courtesy Hirschl & Adler Galleries, New York

PLATE 15. *Winter, Canada,* c. 1906
Oil on canvas, 18 × 20 inches
Collection of Ken and Connie Ward, Carmel, California

PLATE 16. *The Coffee House,* c. 1906
Oil on canvas, 30 × 38 inches
Collection of The Art Institute of Chicago
Gift of Mr. and Mrs. Alson E. Clark
On view only at the Pasadena Museum of California Art

PLATE 17. *State Street Bridge Along the Chicago River,* c. 1906
Oil on canvas, 15 × 18 inches
Collection of Paul and Kathleen Bagley

PLATE 18. *Toboggan Slide and Dufferin Terrace,* c. 1906
Oil on canvas, 30 × 38 inches
Edenhurst Gallery, Los Angeles

PLATE 19. *Plaza of the Puerta del Sol,* 1909
Oil on canvas, 30 × 38 inches
Collection of Paul and Kathleen Bagley

PLATE 20. *The Rising Sun, Malaga,* c. 1909
Oil on canvas, 11½ × 16 inches
Collection of Dr. Albert A. and Sharon M. Cutri

PLATE 21. *Saint Gervais,* c. 1909
Oil on canvas, 30½×38½ inches
Collection of the Union League Club of Chicago

PLATE 22. *Summer, Giverny,* 1910
Oil on canvas, 25¼×31⅛ inches
Collection of Mr. and Mrs. Thomas B. Stiles II

PLATE 23. *In the Garden,* 1910
Oil on canvas, 30×40 inches
Edwin H. Clark Estate

PLATE 24. *Paris,* c. 1910
Oil on canvas, 25×21 inches
DeRu's Fine Arts, Laguna Beach, California

PLATE 25. *Sunset, Normandy,* c. 1910
Oil on canvas, 26×32 inches
Collection of Paul and Kathleen Bagley

PLATE 26. *Thousand Islands, New York,* 1911
Oil on canvas, 25×31 inches
Private Collection

PLATE 27. *Charles Bridge, Prague,* 1912
Oil on board, 7½×9½ inches
Private Collection

PLATE 28. *Over the City, Prague,* 1912
Oil on board, 7½×9½ inches
Private Collection

PLATE 29. *Reclining Nude,* 1912
Oil on canvas board, 15×18 inches
The Redfern Gallery, Laguna Beach, California

PLATE 30. *Rue St. Jacques,* 1912
Oil on canvas, 21½×25½ inches
Private Collection

PLATE 31. *Snow over Prague,* 1912
Oil on board, 7×9 inches
Private Collection

PLATE 32. *Bazaar, Spalato,* c. 1912
Oil on canvas, 38×48 inches
Collection of Pasadena Public Library, California

PLATE 33. *In the Lock,* 1913
Oil on canvas, 25×31 inches
Collection of W. Donald Head/Old Grandview Ranch

PLATE 34. *Panama Canal, The Gaillard Cut* (originally titled
The Culebra Cut), 1913
Oil on canvas, 21×22½ inches
The Delman Collection, San Francisco

PLATE 35. *Panama City,* 1913
Oil on canvas, 21½×25½ inches
Collection of Paul and Kathleen Bagley

PLATE 36. *Pedro Miguel Locks,* c. 1913
Oil on canvas, 38×50 inches
The Buck Collection, Laguna Hills, California

PLATE 37. *Work at Miraflores,* c. 1913
Oil on canvas, 25½×31½ inches
Private Collection
Photo courtesy of The Redfern Gallery

PLATE 38. *First Dredges through the Gatun Locks,* 1914
Oil on canvas, 38×50 inches
Collection of Brad Freeman and Ron Spogli

PLATE 39. *In the Cut, Contractors Hill,* c. 1914
Oil on canvas, 37½×51½ inches
Collection of Brent and Carol Gross

PLATE 40. *In the Lock, Miraflores,* c. 1914
Oil on canvas, 38½×51¼ inches
Collection of Jason Schoen, Miami

PLATE 41. *Moving the Trestles,* c. 1914
Oil on canvas, 35×46 inches
Collection of Paul and Kathleen Bagley

PLATE 42. *Windy Hill Farm, Thousand Islands, Alexandria
Bay,* 1916
Oil on canvas, 26×32 inches
Collection of Ranney and Priscilla Draper

PLATE 43. *Frozen River, Jackson, New Hampshire,* c. 1916
Oil on canvas, 25×31 inches
Collection of Paul and Kathleen Bagley

PLATE 44. *Catfish Row, South Carolina,* c. 1917
Oil on board, 18×15 inches
Collection of Paul and Kathleen Bagley

PLATE 45. *Catfish Row* (also known as *Cabbage Row*), c. 1917
Oil on canvas, 26×32 inches
Collection of Paul and Kathleen Bagley

145

PLATE 72. *Flaming Bushes,* 1930
Oil on canvas, 29×31 inches
Collection of Dana A. Gemmingen

PLATE 73. *Taxco,* c. 1931
Oil on canvas, 26×32 inches
Rowe Family Trust

PLATE 74. *Rooftops, Paris,* 1936
Oil on canvas, 22×18½ inches
Collection of the McNay Art Museum, San Antonio
Gift of Mrs. Alson S. Clark

PLATE 75. *In the Dressing Room,* 1947
Oil on canvas, 28×24 inches
Collection of Terry and Paula Trotter

PLATE B. *Arroyo Seco from the Studio,* 1921
Oil on canvas, 35 × 46 inches
Spanierman Gallery LLC, New York

Index